ONE FACE
FIFTY WAYS

FROM THE TEAM BEHIND YOUTUBE PHOTOGRAPHY HIT **WEEKLY IMOGEN**

ONE FACE
FIFTY WAYS

THE PORTRAIT PHOTOGRAPHY IDEAS BOOK

Imogen Dyer & Mark Wilkinson

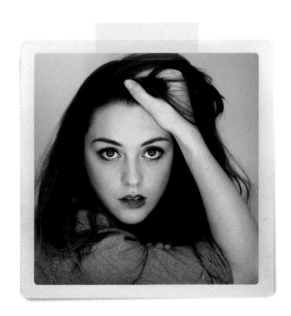

ilex

An Hachette UK Company
www.hachette.co.uk

First published in the United Kingdom in 2017 by
ILEX, a division of Octopus Publishing Group Ltd

Octopus Publishing Group
Carmelite House
50 Victoria Embankment
London, EC4Y 0DZ
www.octopusbooks.co.uk
www.octopusbooksusa.com

Distributed in the US by
Hachette Book Group
1290 Avenue of the Americas
4th and 5th Floors
New York, NY 10104

Distributed in Canada by
Canadian Manda Group
664 Annette St.
Toronto, Ontario, Canada M6S 2C8

Publisher: Roly Allen
Publisher, Photography: Adam Juniper
Managing Specialist Editor: Frank Gallaugher
Admin Assistant: Sarah Vaughan
Art Director: Julie Weir
Design: JC Lanaway
Production Controller: Meskerem Berhane

ISBN 978-1-78157-430-0

A CIP catalogue record for this book is available
from the British Library

10 9 8 7 6 5 4 3 2 1

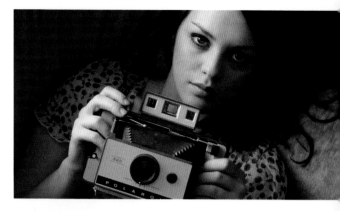
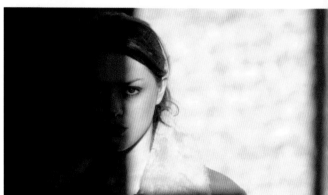

CONTENTS

Introduction 6

THEMES
Try a themed photoshoot 18
Street photography 20
Fake candids 22
Cinematic photography 24
Self-portrait 26
Shoot in the snow 28
Film noir 32
Perfect portrait 34
Mirror image 36
Shoot in a crowd 38

ACCESSORIZING
Use a prop 42
Change your wardrobe 44
Change the hairstyle 46
Makeup matters 48
Little black dress 50

GEAR
Take a Polaroid 54
Film 56
Low resolution 58
Choosing your lens 60

LIGHT
Lighting the face 64
Reflectors 66
Golden hour 68
Shadow 70
Night photography 72
Soft light 76
Hard light 78
Window light 80

TAKING YOUR SHOT
Picking your background 84
Bokeh 88
Color matching 90
Leading lines 92
Rule of thirds 96
Free lensing 98
Shoot through glass 100
Foreground frames 102
Convert to black & white 104
Eyes 106

ANGLES
Shoot at 45 degrees 110
Straight on 112
Get in close 114
Unusual angles 116
Shoot at a slant 118

POSING
Strong 122
Vulnerable 124
Expressions 126
Hands 128
Profile 130

CHOOSING A FORMAT
Portrait 134
Landscape 136
Square 138

DIFFERENT FACES
Try a themed photoshoot 142
Use a prop 144
Change your wardrobe 146
Golden hour 148
Color matching 150
Convert to black & white 152
Shoot at 45 degrees 154
Expressions 156

Index 158
Acknowledgments 160

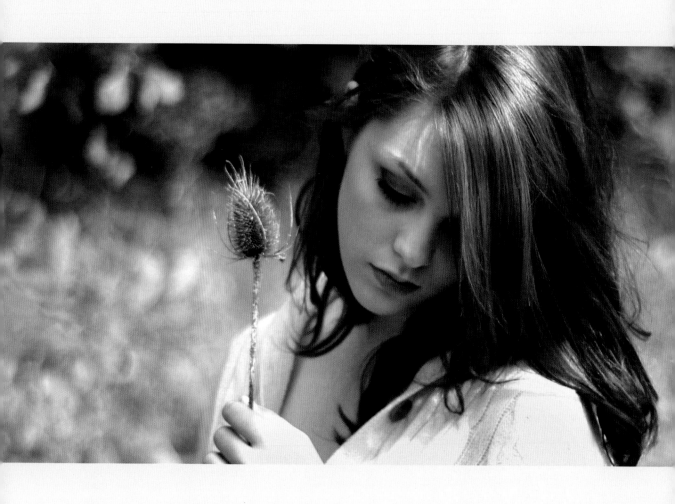

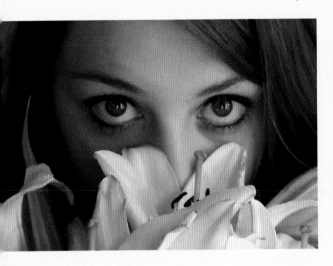 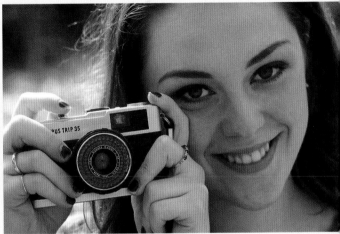

PREPARATION IS KEY | GEAR & WHAT TO PACK FOR A SHOOT

INTRODUCTION

INTRODUCTION

The beauty of photography as an art form is in its immediacy. Photographs provide a snapshot of a moment in time and capture a scene or person in a moment that is fleeting but forever remains in a still form. Our journey with portrait photography has aimed to do just this—to capture the raw and vulnerable essence of human nature in a still, contained image.

Mark has been drawn to photography since he was a teenager, snapping away on film and processing in a dark room. For him, the joy of photography is in its ability to document events in a raw and emotionally impactful way. For his portrait photography, he likes to work with models over an extended period of time, following their journey and capturing an aspect of it on film. This is certainly true for the images captured in this book. The shots of Imogen to date document seven years and are a wonderful visual journey through the period. In terms of themes and style, Mark explores ways that female beauty in all its forms can be captured, focusing on creating an image which is realistic and presents something of the personality and internal state of the model he is working with. He has a life-long love of black-and-white images and their ability to capture texture, shade, and emotion—but he's also drawn to the color green, an aspect that features heavily in the color matching of his images.

For Imogen, one of the wonderful aspects of modeling is to see the photographer's unique depiction of an individual.

"The joy of photography is in its ability to document events in a raw and emotionally impactful way."

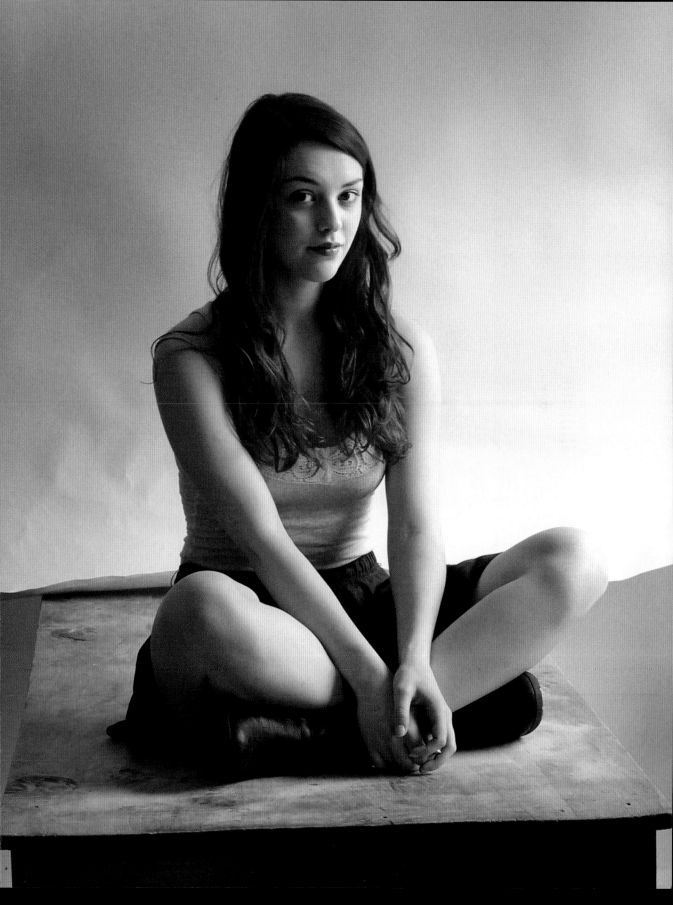

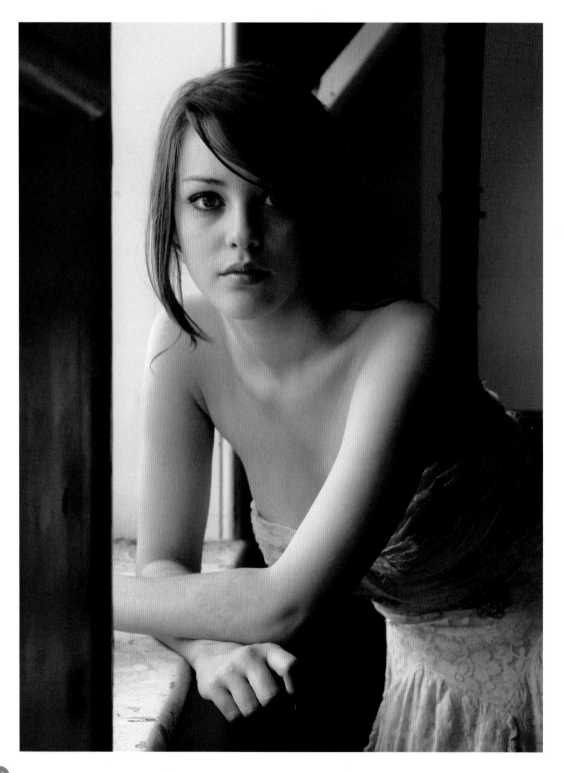

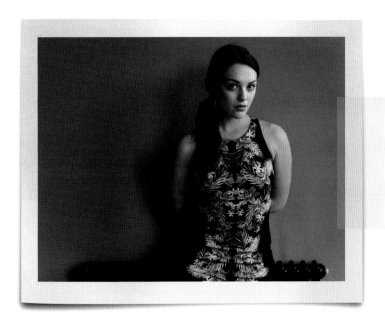

"One of the beauties of photography is that it connects the viewer, the model and the photographer through a visual channel."

Each photographer will display their vision of a model in a personal, stylistic way, and it is fascinating to gain insight into the artistic eye of the photographer and to visually see yourself presented through the eyes of another. One of the beauties of photography is that it connects the viewer, the model, and the photographer through a visual channel, each bringing something of their own emotion and personality to the image. This linking of three individuals creates a sense of intimacy and lasting impact.

Photography and the process of working with a model is a wonderful journey of developing a human relationship and exploring all the complexities, joys, and fragilities of human nature—capturing these in a still and lasting image. Through exploring the many different ways to shoot an effective portrait, model and photographer are able to work together to find the most creative ways to capture something of the human spirit. This book demonstrates some of these techniques, providing practical ideas for photoshoots without the need for expensive equipment.

PREPARATION IS KEY

We believe that the key to a successful photoshoot is careful preparation. It is important to have clear communication with the model before the shoot to ensure that the times, location, and necessary looks that you need are clear and prepared for. Make sure that you have clarified all of the arrangements and that you are both clear what items each of you need to bring. This will allow both photographer and model to feel at ease on the shoot.

As a photographer, visit the location where you are shooting the day before, to find the locations you wish to use for each shot and to test the light. When using natural light, an element of spontaneity will always be needed and it is creatively important to embrace the moment when on a shoot; however, shoots are usually most successful when the basis of the day has been thought through and considered.

To help with the spontaneous moments on a shoot, Mark uses an ideas book. This is a compilation of images that he finds inspiring or wishes to emulate. He uses paper notebooks that he fills with cutouts from books, the internet and magazines, although an ideas book could also be created online. Inevitably, there will be moments on a shoot when both photographer and model are stuck in the same cycle of poses and expressions and need some visual stimuli to kickstart new ideas and patterns of working. By turning to an ideas book, you can reignite your creative juices and help visually explain to a model the look you are trying to achieve. We hope that this book will be able to act in some way as an ideas book for your own portrait photography.

"It is creatively important to embrace the moment when on a shoot; however, shoots are usually most successful when the basis of the day has been thought through and considered."

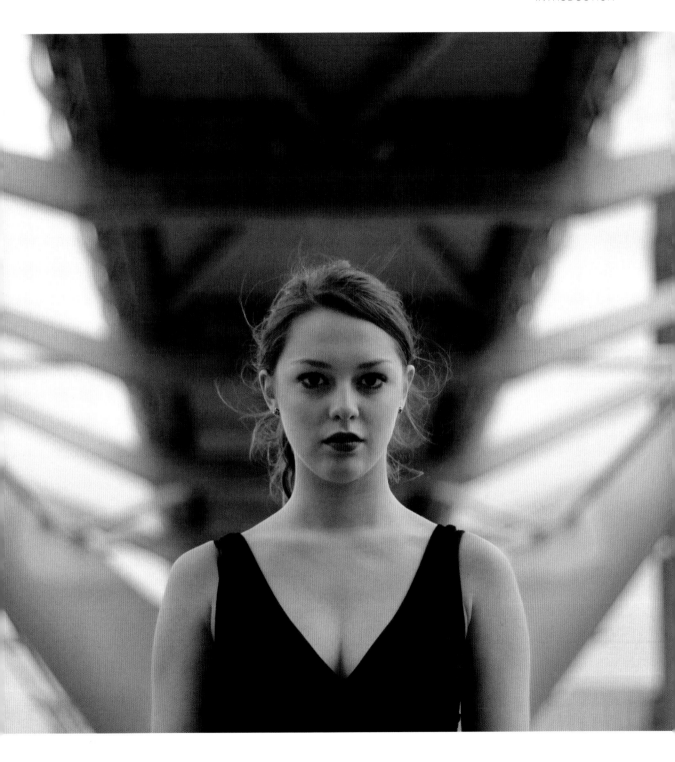

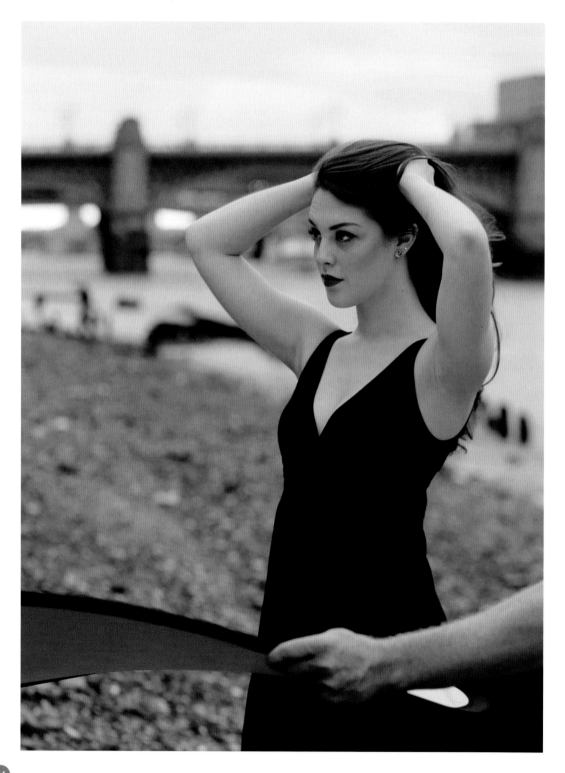

GEAR & WHAT TO PACK FOR A SHOOT

As we tend to work with natural light and like to be mobile on shoots, we pack as light as possible. We work to the ethos that less is more and that good photography requires preparation, practice, and vision rather than expensive equipment. We often use a variety of props and clothes for the shoots, with a particular focus on color matching, and buy them all second hand. For most photoshoots we use a Canon 6D with an 85mm lens or a Canon Rebel T2i/550D with a 50mm lens. Until recently we shot almost exclusively with the Canon Rebel. Although we love the new full-frame camera, you don't necessarily need to invest a huge amount of money to take great shots. We also pack a low-resolution camera, a small-lens film camera, and a Polaroid camera. Additionally, Mark packs spare batteries, a reflector, an ideas book, and some comforts for the model such as water, scarves (if it is likely to be cold), and, of course, some chocolate.

For the model's toolkit, Imogen packs a small makeup bag containing enough to touch up a versatile makeup look and lots of different color lipsticks to quickly change up an image. She also packs makeup remover, a large mirror, hair bands and slides, and a change of outfit. It is good to turn up in a versatile coat and shoes that can easily be worn with any outfit. For both the model's and the photographer's bag, the emphasis is on traveling light to make the shoot as quick and easy as possible. By pairing down the amount of technical gear that we bring, it helps us to focus on the composition and emotion behind each shot so we can create an image with immediacy and emotional and visual impact.

"By pairing down the amount of technical gear that we bring, it helps us to focus on the composition and emotion behind each shot."

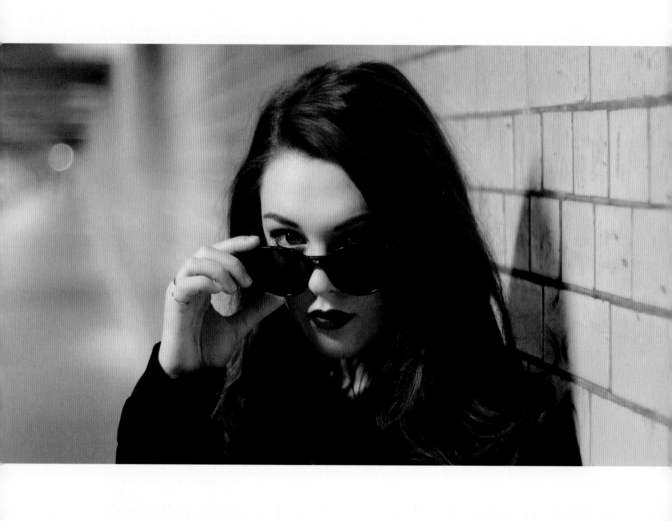

THEMES

TRY A THEMED PHOTOSHOOT | STREET PHOTOGRAPHY | FAKE CANDIDS | CINEMATIC PHOTOGRAPHY | SELF-PORTRAIT | SHOOT IN THE SNOW | FILM NOIR | PERFECT PORTRAIT | MIRROR IMAGE | SHOOT IN A CROWD

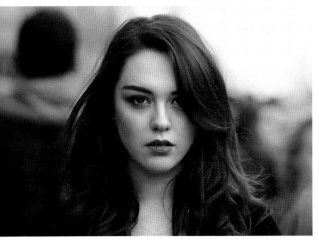 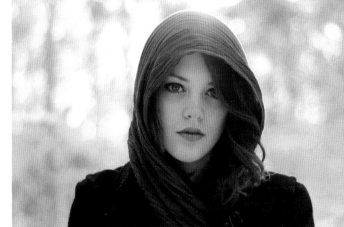

TRY A THEMED PHOTOSHOOT

Setting boundaries can often be a great way to inspire creativity. By setting a theme for a photoshoot, the restriction can help create space in the mind to try new ideas, poses, and settings with the model and your photography. Themes can be based around a style, an artistic movement, a location or a story.

Here, we have a simple blue theme. A blue outfit has been used and locations planned that all feature the color in the background. The color matching (see page 90) throughout helps to create a cohesive and well put-together image.

A themed photoshoot requires a little planning as you will need to find locations, outfits and have an idea of the images you want to achieve before setting out. However, although there can be more work before you get out with your camera, having a list of photos you want to achieve within your theme can make the shoot itself easy and smooth. Make sure to let the model know your theme and send some examples of what you're trying to achieve so they can plan hair, makeup, and outfits accordingly.

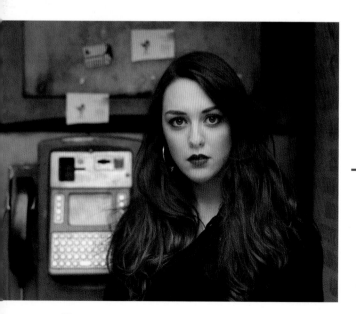

Top tip! Plan ahead and pack some simple props and accessories for the images that fit with the theme. This will help to set the mood for the shoot and can also be fun for the model to interact and pose with.

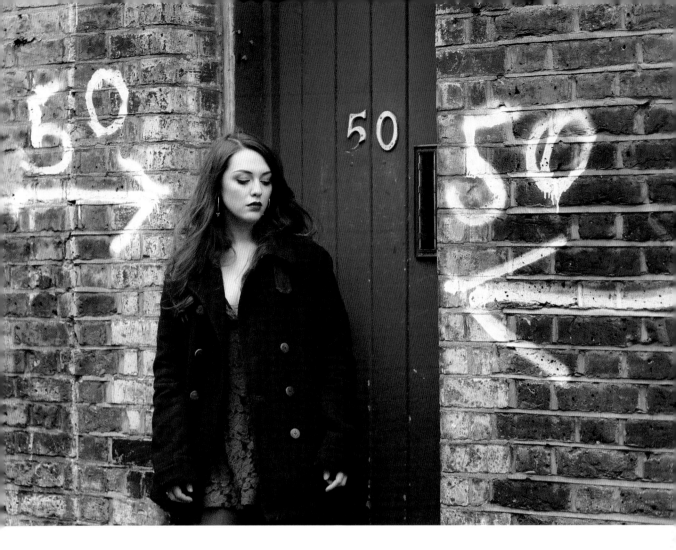

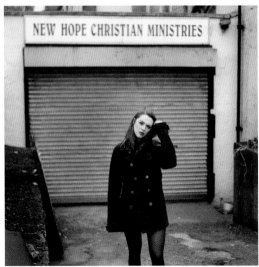

"The theme ties together all of the photos taken throughout the shoot so they create a linked series together."

STREET PHOTOGRAPHY

Street photography is a vibrant and lively form of photography where real-life encounters, moments, and scenes are captured. Although street photography is traditionally taken candidly, you can create interesting and lively posed portraits by incorporating some of the settings and ideas.

When shooting in particularly busy settings, it is important to consider the timing of your shoot. Although it creates a lovely effect to have the out-of-focus silhouettes of passersby in the background, if it is too busy, it becomes difficult to work effectively. Try to head out early in the morning to make sure you can get the most from your location. As it can often be busy with lots of other people around, make sure you have a clear vision for the shoot before heading out and dress the model in a fairly plain outfit so it will work with any background.

Make the most of objects and settings you come across while on location. Textured walls with graffiti can make a really lively, urban background for your image. Phone booths can also be used

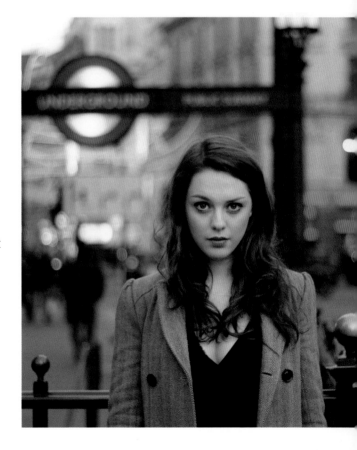

"As it can often be busy with lots of other people around, make sure you have a clear vision for the shoot before heading out and dress the model in a fairly plain outfit so it will work with any background."

to great effect to provide a really strong frame for your photo. By asking the model to act as though they are using the phone, you can introduce an element of storytelling to the image and nod to the candid feel of street photography.

+ Top tip! Markets provide a great location; the backgrounds are energetic and candid. Make sure to ask the stall owner before taking the photo!

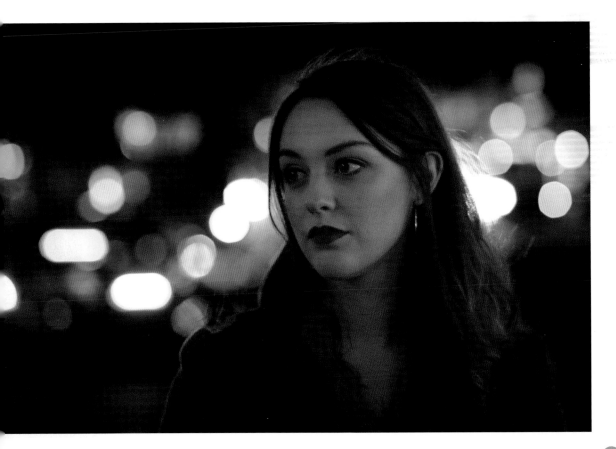

FAKE CANDIDS

Candid photography is where an image is natural, unposed, and often taken without the subject's knowledge. In portrait photography, you can create a fake candid shot that gives an impression of naturalism and reality. With fake candid photography, perseverance is key. It can be challenging to capture a beautiful shot that also feels unposed and therefore you'll need to take plenty of shots and be prepared to discard lots after the shoot. However, when you get a shot that works it can be a real show stopper, so it's worth the persistence!

A simple method to create a fake candid shot is to get the model to look away from the camera. Asking the model to look somewhere into the middle distance or down to the side will create a distant, vacant look that gives the impression of catching the model in their own space. Incorporating hands into the image, for example playing with hair, helps to create the impression of the model in the midst of something natural and unposed.

"When you get a shot that works, it can be a real show stopper."

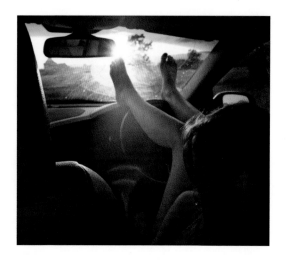

You can also use location and props to tell a story. Placing the model in a scene that you have set to look naturalistic will create the impression of the photographer stumbling across the model during an ordinary activity. In the example right, where the model is placed in a car and unengaged with the photographer, it seems as though the photo could have been taken without her knowledge.

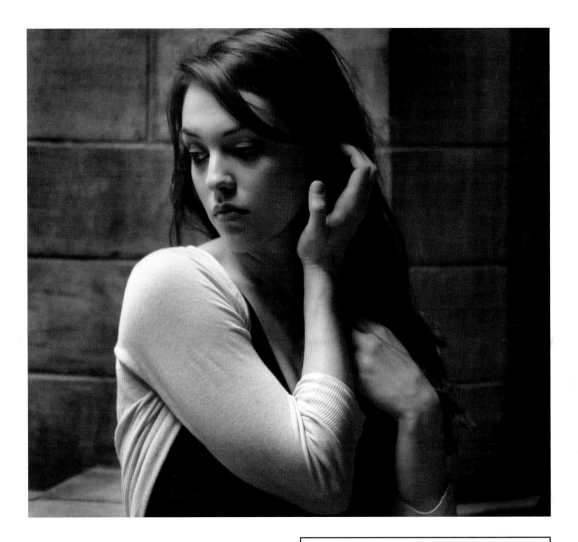

Adding props, such as a book or phone, helps to create a candid image and can also help the model to work more with the object than with the camera. Make sure that the model is engaged with their own activity or pose rather than engaging directly with the camera to give the candid feel.

Top tip! When on a shoot, always try to take some genuine candid photos of your model while they're touching up their make or looking at their phone. The key here is to make the model carry out a normal activity, not just pretend to do it.

CINEMATIC PHOTOGRAPHY

Some of the most visually interesting images that have a lasting emotional effect on the viewer are those that tell a story. Creating a cinematic photograph is not about technique, but rather about storytelling and creating a mood. A particularly strong impact comes when there are elements left untold that leave the viewer questioning what came before and after. It often helps to think about a backstory to the image or to imagine you are creating a still from a film.

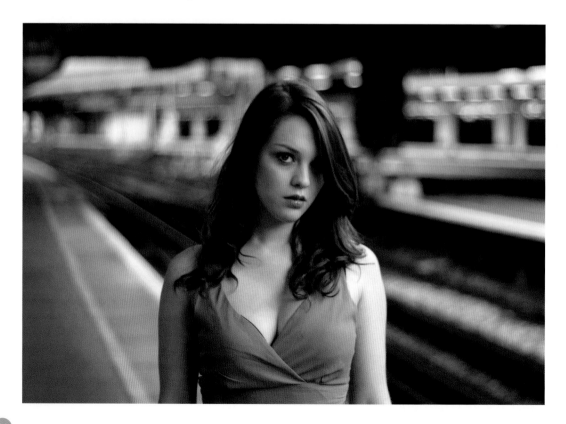

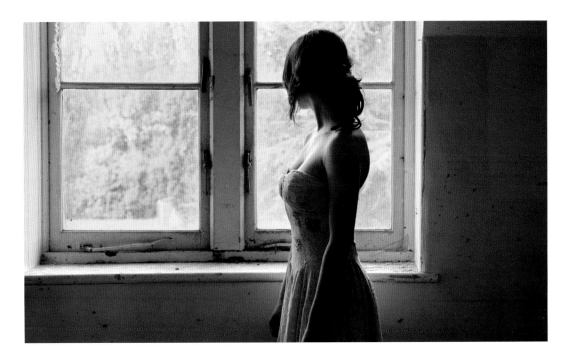

Where it is usually preferable to search for soft, even light when taking natural light portraits, in cinematic photography it can be hugely effective to incorporate harsh light and shadow to create a stronger, more emotive image. By casting shadows across the model's face, or by obscuring some or all of the model in shadow, you can create a more ominous feel to the photo. An image where the unexpected or unusual is included will encourage the viewer to ask questions.

Location is hugely important when storytelling within an image. Street shots and stations work particularly effectively for cinematic photography as the element of coming and going begs for a story to be told. Shooting by a window can also be incredibly effective, particularly if the model is gazing out of the glass. This draws the viewer's eye outside with the model and creates a longing feel.

+ Top tip! Consider the model's gaze and expression. You may want to ask the model to be more emotive than usual and an element of acting will come into play. Looking away can be an effective tool in getting the viewer to look deeper into the photograph.

"An image where the unexpected or unusual is included will encourage the viewer to ask questions."

SELF-PORTRAIT

Self-portraits are a fantastic way to add a more personal element to your portfolio. As a photographer you will usually be shooting someone else and will yourself remain invisible in your photographs. Taking self-portraits are therefore a fantastic way to add a physical and personal flair.

Self-portraits are most effective when they capture something of the moment and feeling of the time. This creates a more intimate and interesting image for the viewer as they can look deeper into the character and emotion presented and begin to build a story around the image. To enhance this effect, try to include something meaningful in the background— whether a location or object—which reminds you of the time or feeling. Capturing something personal will also create a more interesting image to look back on over the years to come.

Try setting up on a tripod and using a self-timer to take the image. Alternatively, you can take fantastic self-portraits using mirrors or reflections in glass windows or shop fronts. These images are particularly interesting as it feels as though there is an extra level of separation that allows the viewer to ask more questions. If you have a smart phone, using the camera on the front of your phone is a fantastically easy and accessible way to take a self-portrait. Take lots of photos so you can choose the one which best captures the essence of you at the time.

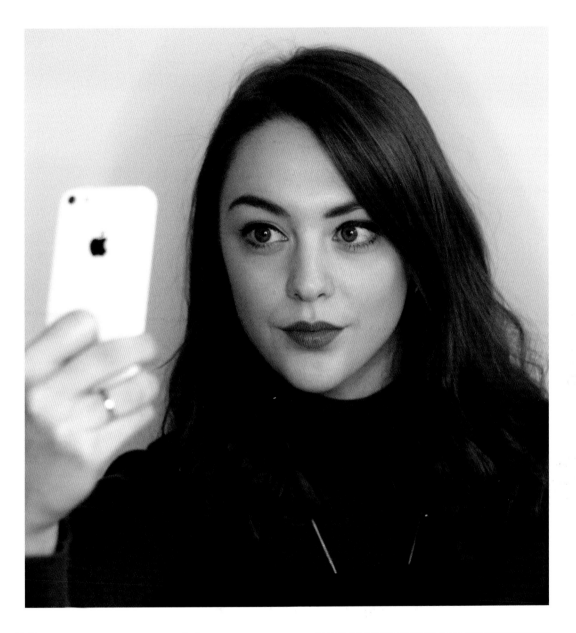

"Capturing something personal will also create a more interesting image to look back on over the years to come."

+ **Top tip!** When working with a model, ask them to take a self-portrait on the shoot. This can be a fun, quirky, and more personal image within the selection from the day.

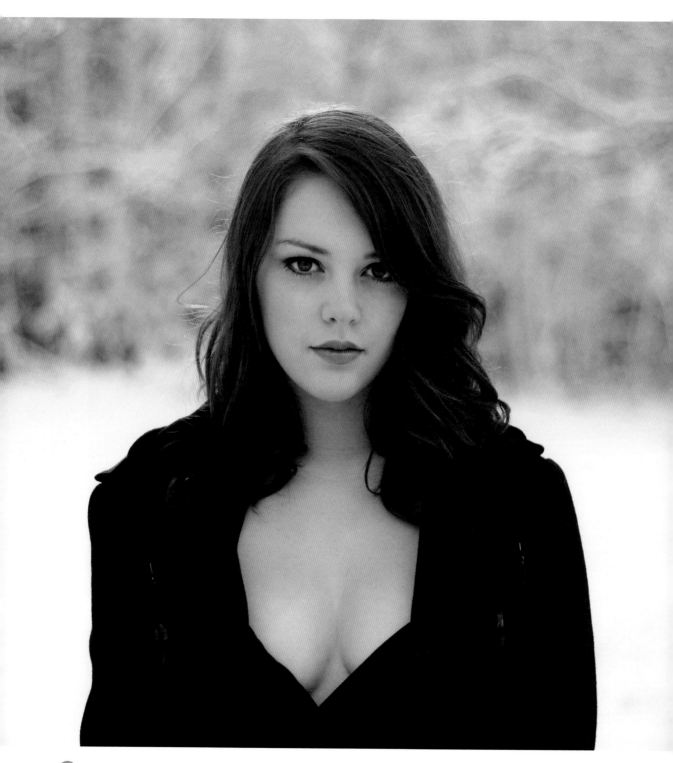

SHOOT IN THE SNOW

The snow not only looks beautiful in itself, but can also provide a wonderful location for a photoshoot. Try to get out early in the morning or just after a fresh layer of snow has fallen so you can really make the most of the picturesque and untouched landscape.

Shooting in the snow creates beautiful portraits as the white surroundings work in the same way as a handheld reflector. The light bounces back off the snow onto the model, highlighting the face. As the light can be so bright in the snow, you do need to be aware of lens flare from the light bouncing back. This is often unavoidable, but can be used to great effect as part of the image. Spots of blue light across the picture can be used to add to the magical, fairytale effect. To enhance the feel of your snow photography, try shooting during the golden hour (see page 68) for a golden glow surrounding the crisp, white setting.

You can also create beautiful foreground frames (see page 102) with snow on branches and leaves. In the example on the right, a snow covered twig falls in front of the face, naturally shaping the contour of the cheek. By featuring the snow behind and in front of the model it also creates an added feeling of depth to the picture.

> "Spots of blue light across the picture can be used to add to the magical, fairytale effect."

Top tip! Plan ahead. It can be very cold and you need to make sure you optimize your time so the model doesn't get too cold. Pack scarves, a blanket, and possibly a flask of hot water, tea, or similar to help warm up between shots. It may be impractical to have extravagant costume changes so try to keep it simple—a colored scarf can create a new look without the need to change in the cold.

When shooting in the snow, try using a low depth of field to create a beautiful, hazy, and wintry background. By blurring the background, the model will naturally pop out of the image while maintaining the snowy effect behind. Additionally, setting your camera to overexpose the photo slightly will help enhance the beautiful white surroundings. Increasing the exposure will ensure that the snowy landscape is as bright as possible. Often, when a camera is set to autoexposure, the photos will turn out slightly gray and dim as the camera compensates for the exceptionally bright surroundings.

In post-processing, try increasing the saturation. As photographs taken in the snow often contain a large portion of white, by making the available color more intense, you will create a more striking image with strong definition and contrast. This will also help to make any objects or people within the image seem better defined.

A point of caution when shooting in the snow—although falling snow is beautiful, it can wreak havoc with your camera. If the snow is falling heavily, make sure you protect your camera from the moisture. The cold weather can also affect your cameras batteries so it is worth packing spares. Preparation is key to your snow shoot to minimize problems with your camera and to avoid both you and the model getting too cold. Plan your locations and the shots you want to take in advance so you can move through the shoot as quickly as possible.

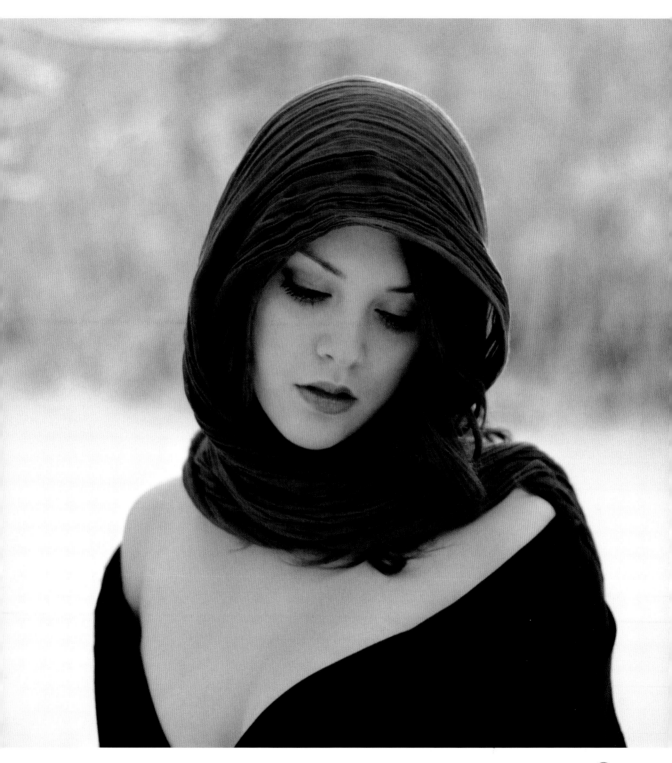

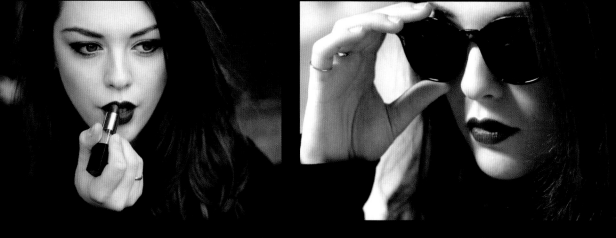

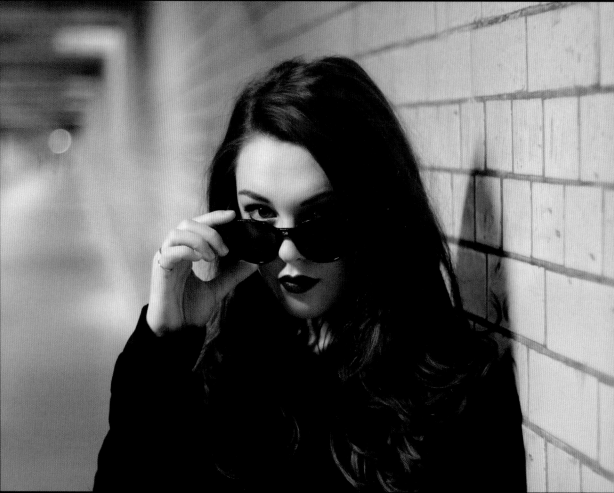

FILM NOIR

Film Noir was a term used to describe the dark, menacing thrillers and detective films that were hugely popular during the 1940s and 50s. The style, often in black and white, creates incredibly striking, cinematic images. A film-noir photoshoot is enormously creative, fun, and a great way to expand your portfolio.

When heading out on a shoot it can be useful to create a storyboard for the images you want to create during the day. Following a storyline can help the model to get into a dark and sinister film noir character. If not using a storyboard, some visual stimuli—shots from films or similar photos you want to create—can be a really useful starting point.

Wardrobe, hair, and makeup are fundamental to creating a really strong film-noir feel. Dark-colored fabrics and trenchcoats work particularly effectively for a detective look. If working with a female model, ask them to wear dark, smokey eye makeup and a deep red lipstick. Props, for example, sunglasses, secret documents, and books to spy on from behind, also help to tell your film-noir story.

> ## "Emphasizing darker elements of your photo will also help to enhance the sinister feel."

Location is hugely important for a true film-noir feel, so take the time to explore before your shoot. Tunnels can work particularly effectively for a cinematic touch, as there is a sense of traveling through the space and the leading lines (page 92) draw the viewer's eye into the photograph. Emphasizing darker elements of your photo and using shadows will also help to enhance the sinister feel. By setting a low depth of field, you can use the out of focus silhouettes of passersby in the background to create the effect of the model being watched.

+ Top tip! Try shooting some of the photos in black and white or converting them in post-production for a classic film-noir feel.

33

PERFECT PORTRAIT

Portrait photography focuses on a model's face and aims to capture some of their personality and emotion within the image. A classic portrait often zooms in tighter on the model's face and shoulders to create this sense of personal intimacy. Portrait photography incorporates many of the features included in this book, however, below are a few top tips for creating a perfect portrait.

A major feature of a perfect portrait is the composition of the image. The viewer's gaze should be drawn to the model. It is particularly effective to use the eye as a focal point as the eyes often give an intimate feel of emotion and character. Following the rule of thirds (see page 96), place the model's face in the top third of the picture—this helps the viewer's gaze to travel toward the eyes.

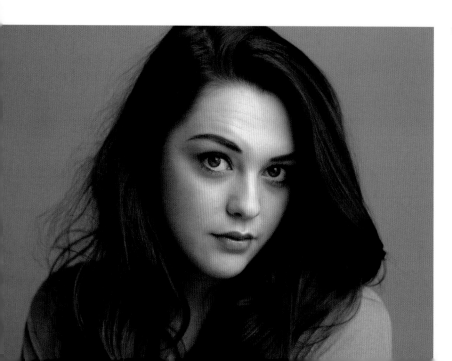

"Try lots of different expressions so you can capture the moment where the model is most natural."

As portrait images will be focusing on the face, really take the time to consider the lighting and background. An uncluttered, plain background is best to allow the model to be the obvious focal point. When using natural light, try placing the model in front of the light source so that the face is in soft shadow. This will make the skin look even and the model will be able to open their eyes as wide as possible without squinting. If the sun is stronger, you can also achieve a beautiful halo effect on the hair with the sun shining through in the background.

+ Top tip! For a striking portrait, try a tight crop and fill the image with the model's head and shoulders. A square crop lends itself well to this.

It is important for the model to feel at ease so they can allow some of their personality to shine through. Make sure you set aside enough time to take plenty of photos. Try lots of different expressions so you can capture the moment where the model is most natural.

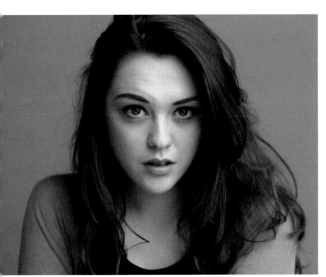
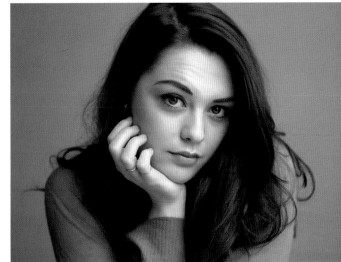

MIRROR IMAGE

When viewing a photograph, we often look through the eyes of the photographer. We experience the image through the artistic eye of the person creating the image. A fun and different way to mix up the perspective of your portraits is to shoot into a mirror. This switches the focus to seeing what the model sees and creates a candid and intimate feel.

When shooting with a new model, a mirror shot is a great way to make the model feel relaxed and at ease. In most photoshoots a model is unable to see what they look like until they receive the images back from the photographer; however, when shooting a mirror shot, they will be able to see their pose and expression before the photo is taken. After setting up the image, make sure to ask the model to return their gaze to the camera before taking the photo.

Top tip! Watch out for dust and smudges. It is useful to pack some cloths and glass cleaner to make sure you get a crystal-clear image.

"Make sure to ask the model to return their gaze to the camera before taking the photo."

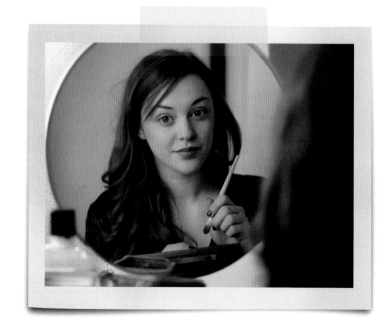

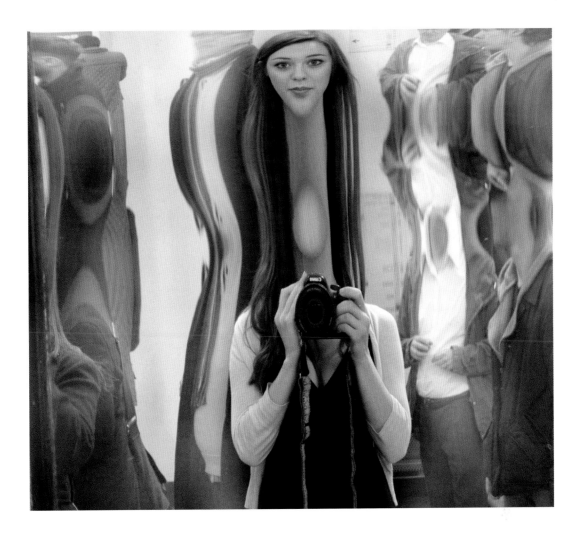

To incorporate the mirror into the image, ask the model to pose in a natural way—for example, doing their hair and makeup. This will create a reason for the mirror in the image as well as emphasizing the candid feel to the image. By including the back of the model's head or body in front the mirror you will be able to create a feeling of depth and context to the image.

Mirrors provide a fantastic natural frame. Try experimenting with different shapes—a circular mirror can look particularly effective if shooting a classic head-and-shoulders portrait. As well as framing the image, mirrors are also a great natural reflector. The reflective surface will flood light back onto the model's face creating a beautiful, bright image and can help to even out the light across the model's face.

SHOOT IN A CROWD

Shooting within a crowd is a challenging but rewarding form of portrait photography that works to create a feeling of movement and story. Such shots can be emotive and powerful, with an isolated and lonely feel as though the model is lost among a sea of people.

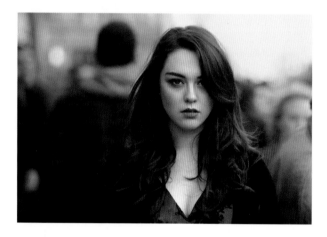

Crowd shots often require a lot of patience as people will frequently walk in front of your lens, and both you and your model will need to be relatively fearless so as not to be put off by the people around. In particularly busy areas, it may also be useful to head out early in the morning so you can miss the busiest times of day when it may become impossible to shoot.

"Both you and your model will need to be relatively fearless."

When shooting within a crowd, you will want to focus in on the model and use a shallow depth of field so the mass of people behind and any lights are out of focus. This will enhance the sense of movement and also allow the model to really pop out of the image and remain the focal point. To focus the attention on the model further, consider placing them in an outfit or color that jars with the surroundings.

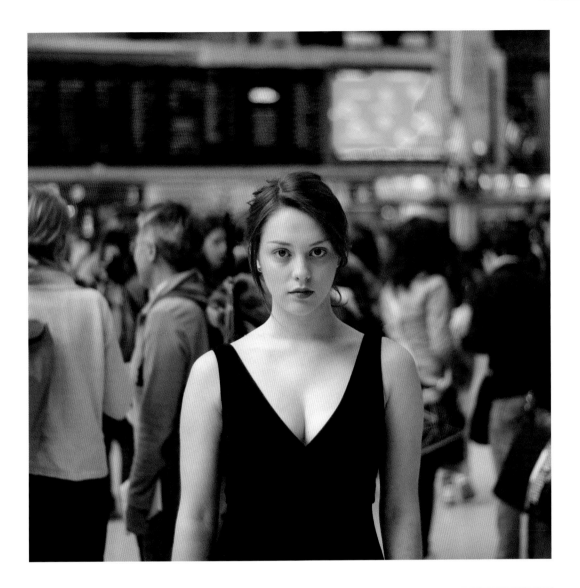

Stations and shopping streets in towns and cities can often be some of the best places to shoot within a crowd. There will always be plenty of movement within these settings that will allow you to get a good blur in the background. You can also shoot an effective crowd shot on a bridge or tunnel. This not only channels and controls the shape of the crowd, but also creates a leading line (see page 92) that draws the eye.

Top tip! When shooting on a high street, the glass fronts of the shops will reflect light onto the model to highlight the face and hair.

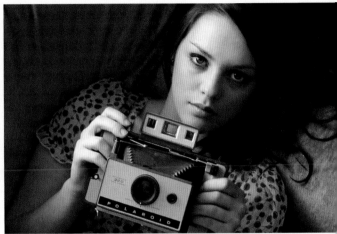

USE A PROP | CHANGE YOUR WARDROBE | CHANGE THE HAIRSTYLE | MAKEUP MATTERS | LITTLE BLACK DRESS

ACCESSORIZING

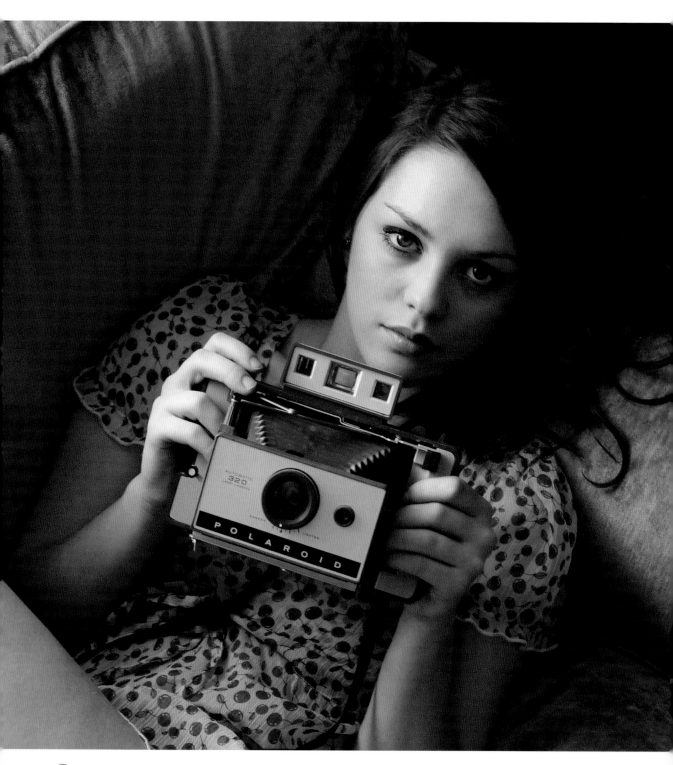

USE A PROP

Props are a great way to add an extra level of interest to your photos. They can instantly help you to tell a story or to provide an extra level of interest or curiosity. When working with a model, it can also be a fun way to relax them into a shoot and spark new ideas for poses and expressions.

Find ways to incorporate your prop into the photo. A beautiful object can be a wonderful focal point of an image, but will jar without proper consideration for how it fits. I think about what the prop portrays visually, and then use this as inspiration for your photo. Consider how the prop may be used in real life and use this for the basis of the poses, expressions, and even locations.

Alternatively, if you have a really strong object, you can choose to make the prop the main focus of the image. Make sure the model is in a plain outfit such as white or black to make sure the item really stands out. To draw the eye to the prop, ask the model to move their gaze toward it as well—the viewer will then follow the model's gaze.

The model doesn't necessarily need to be holding the prop or making a big statement with it. Consider using props as part of your background to tell a story or create a more interesting image.

"Think about what the prop portrays visually and then use this as inspiration for your photo."

+ **Top tip!** Color matching (see page 90) with your prop will make it feel cohesive and uniform within the picture.

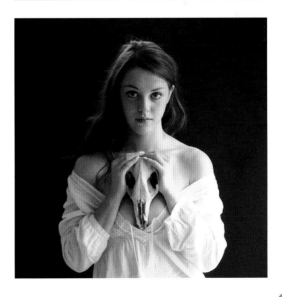

CHANGE YOUR WARDROBE

An easy way to create an entirely new image when on a shoot in a single location is to change up the wardrobe. Different fabrics can help project different moods and feelings in a photograph. A floaty, flowery fabric can portray a very feminine feel, whereas tight-fitting black clothes and leather jackets can give a more edgy vibe. Try to match the outfit with your surroundings to create a cohesive image.

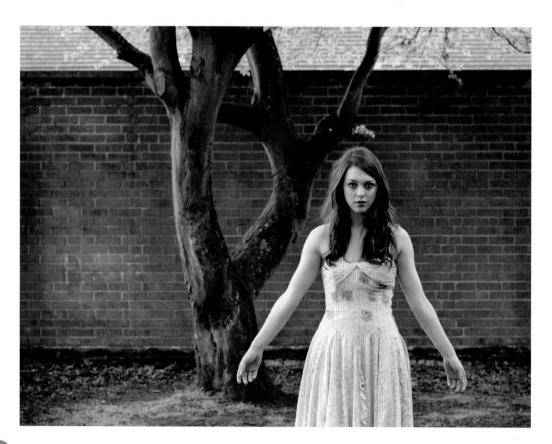

"A clash of styles and conventions forces the viewer to ask questions and create a storyline as to how the model arrived where they are."

Alternatively, by juxtaposing the outfit and the setting you can invite the viewer to look deeper into and ask questions about the image. For example, try pairing formal items such as ball gowns with a derelict setting. The clash of styles and conventions forces the viewer to ask questions and create a storyline as to how the model arrived where they are.

A wardrobe change can not only change the mood of the shoot or refresh a background but can also make the model look entirely different. If working over a long period with a model, or shooting lots of different photographs on the same day, try mixing up style and color to get a versatile and varied selection of images.

+ **Top tip!** Changing the wardrobe doesn't necessarily mean that you need to pack a big suitcase of different clothes. If packing light, try throwing an alternative lightweight dress in your kit or a coat which can be put over the top of a model's outfit. Scarves can also add a pop of color.

CHANGE THE HAIRSTYLE

A model's hairstyle can very quickly and easily change a look on a shoot, even when shooting in the same location and with the same outfit. Straight hair, curly hair, and beachy waves can all bring a different look to a model's face as well as creating a stronger or more relaxed feel to an image.

Before going out on a shoot, find some pictures of hairstyles you'd like to create and send them to the model. It is important to remember that the more complicated the hair style, the more time it will take to set up and the harder it will be to change to another look without a stylist, so make sure you plan accordingly.

When working with a model with long hair, you can completely change a look by asking the model to tie back their hair. Loosely tying the hair can create a relaxed feel, whereas tightly pulling it back can create a sleeker, severe look. You can also create a younger feel by using stereotypical styles like pigtails and plaits. Consider the location, outfit, and overall theme for the shoot and ask the model to change their hair to fit with the photo.

If you don't have a hair band or hair clips available, ask the model to hold their hair up or to the side with their hands. Placing the hands up and under the hair can also create more volume in the hair. This can be a fun way to add some movement to a sequence of images by getting the model to play with their hair while you snap away. By bringing the arms up you will also create extra shape and interest to the picture.

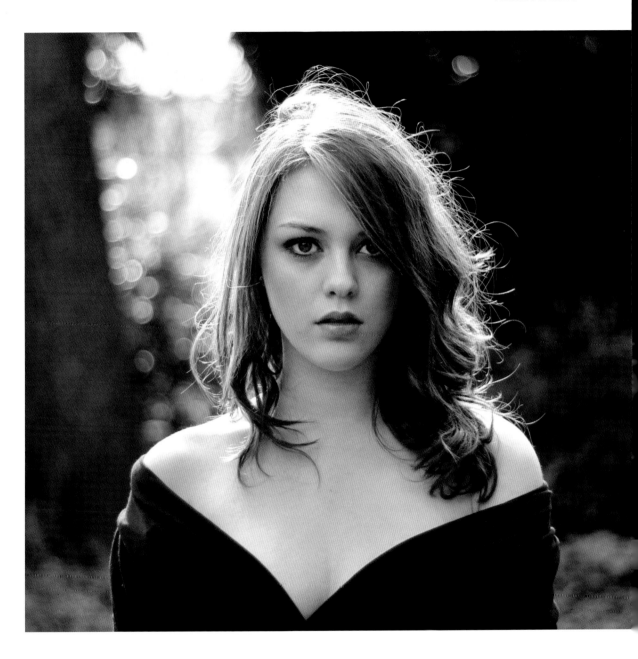

+ **Top tip!** Add a hair band to your kit. It's small, light and will easily allow you to change any look.

"Consider the location, outfit, and overall theme for the shoot and ask the model to change their hair to fit with the photo."

MAKEUP MATTERS

Makeup is powerful way to instantly enhance the look of a model. Simple changes like a bright lipstick can quickly change the mood of a shoot or help to draw together a picture.

Deep red lips are perfect for a sophisticated or film-noir look (see page 34). A darker, purple-hued shade can instantly create an edgier vibe. Lipsticks are also a fantastic tool for color matching (see page 90). For example, pairing an orange lip with the orange trim on a coat or an object in the background can very simply make a model seem more consistent with the location in which they are placed.

If you are keen for the eyes to be the focal point of the photography, make sure the model is using makeup to enhance their eye shape and color. Eyeliner can be used to frame the eye and make them more obvious and defined. Mascara and fake eyelashes can also be used to make the eyes seem bigger. If you are keen to

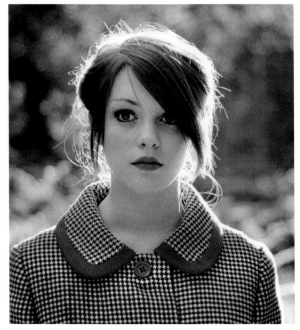

highlight the color of the model's eye, ask them to use an eye shadow on the opposite end of the color spectrum to really make the eye pop. For example, a touch of purple eye shadow helps to make green eyes appear more vibrant.

Blusher and contouring products can also be used to artificially alter the shape of the model's face. For example, a small amount of contour underneath the model's cheekbones gives the impression of an accentuated bone structure and a more chiseled face. Ask the model to bring several different makeup products and colors with them and make sure to pack some makeup wipes for quick changes and touch-ups throughout the shoot.

Top tip! Makeup doesn't necessarily need to be heavy or obvious. Ask a model to arrive to the shoot with a "no-makeup" look (a little foundation and blusher) or with no makeup at all for a more natural image. It is quicker to add makeup than it is to take it away!

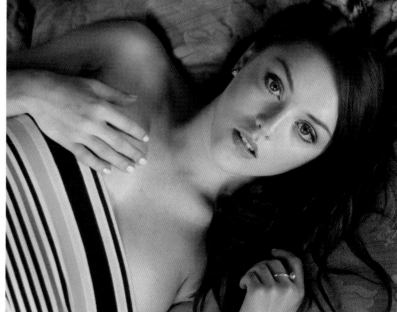

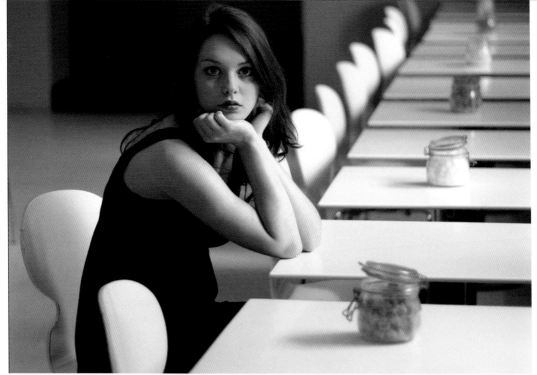

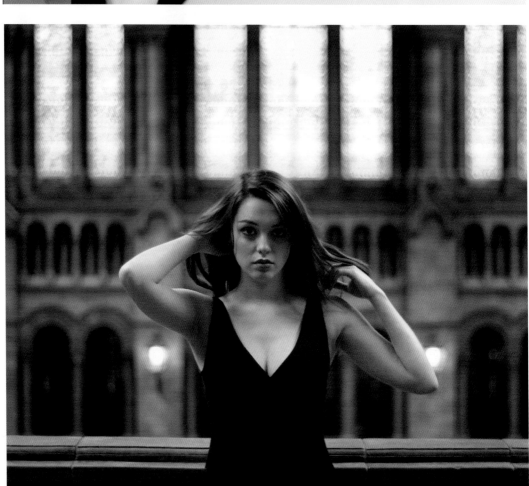

LITTLE BLACK DRESS

The little black dress is an iconic clothing item that is not only a consistent fashion staple but also an incredibly useful and versatile item for photoshoots. Although changing your wardrobe (see page 44) can be a great way to add variety, if keeping a shoot simple or packing light, a plain block shade such as black or white can be perfect for use in any location.

A simple, black dress allows you to shoot in any location and to still make the clothing seem cohesive with the setting. When shooting in front of a colored or busy background, a simple shade will allow the model to remain separate from the surroundings and not to clash with the colors and shapes behind. The solid color will also help to define the model's outline and allow them to pop as a distinct and central feature.

As well as helping draw the eye to the model, a simple black dress will allow the model's face and skin to be the highlight of the photo. By using a simple, non-distracting outfit, the viewer's focus will zoom to the model's face, making it the focal point of the image.

+ Top tip! A model doesn't need to be in a dress. Simple, plain black trousers, skirts and tops can also work to the same effect. If you need the model to be in a colored or patterned outfit, a black coat can also be a useful item to pack for versatility on the shoot.

"By using a simple, non-distracting outfit, the viewer's focus will zoom to the model's face making it the focal point of the image."

GEAR

TAKE A POLAROID | FILM | LOW RESOLUTION | CHOOSING YOUR LENS

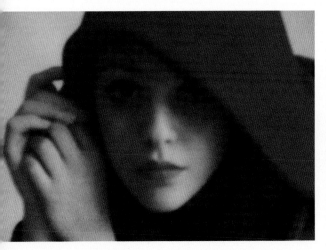
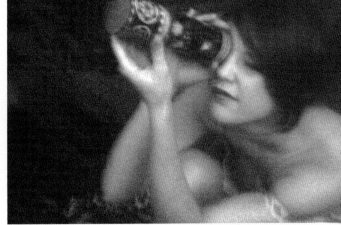

TAKE A POLAROID

Taking a Polaroid is a fun and instantaneous way to capture a moment with a model. Polaroid allows the model to see the finished product during the shoot, providing a good way for you both to get a flavor of what the finished product will look like. Particularly when working with a model for the first time, this can be a great icebreaker.

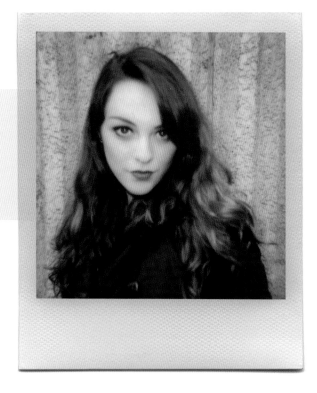

Polaroids have a special charm in the physical nature of the photograph. The film often creates a hazy, soft effect that provides a vintage, fairytale look that can be very effective. Due to the slightly washed-out nature of the film, Polaroids look great if working with strong, block colors as illustrated in the pictures here. In most cases, you'll get the best results shooting a portrait with your Polaroid camera, however don't let that hold you back from trying full body shots too!

As well as creating a physical photograph that both model and photographer can cherish, you can also make your Polaroid unique by getting the model to sign the white space around the image, or by writing comments on the date and location the photograph was taken. This creates a lovely record of the work you have produced over time.

"Due to the slightly washed-out nature of the film, Polaroids look great if working with strong, block colors."

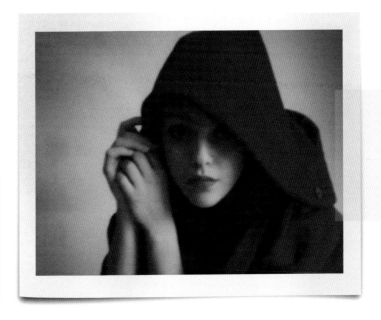

+ **Top tip!** Try scanning your Polaroid to create a version you can digitally share. A small amount of post-processing using your editing software can really help the image to pop on the screen.

Although Polaroid photos don't provide the crisp, sharp effect achieved by digital cameras, they do create a quirky, unique, physical photograph. The creamy hues to the photographs help to create a totally new effect that can breathe new life into your photography!

FILM

Shooting with film is a fantastic way to add a vintage, creative look to your portfolio. One of the truly magical features of film is waiting for the physical images to be developed. The process of shooting a whole roll, letting it develop, and viewing the photos after the event holds a certain charm and can be an incredibly exciting process. The images feel less disposable and for this very reason, using film can focus the mind and provide the right amount of creative pressure to only shoot the winning shots.

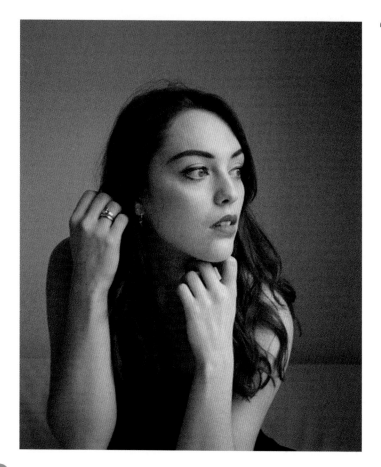

"Waiting for the film to be developed adds an air of mystery and excitement that will help your photography to stay fresh and passionate."

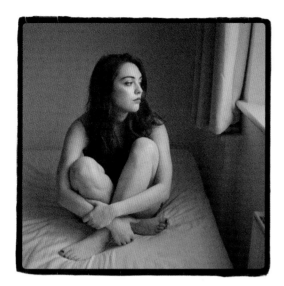

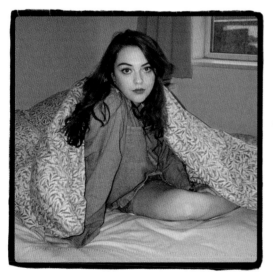

When shooting with film, you don't necessarily need to invest in expensive equipment. The photos featured here were taken with a small-lens camera and Kodak film, and have a wonderfully candid feel. The grainy nature of the photos gives them a personal charm and an immediacy that a high-resolution image may not achieve. The same effect can be created with a disposable camera. These are a great extra tool to carry with you on a shoot. The cameras themselves are very light and easy to operate and provide a simple tool to get a different effect out of the same location and pose.

When shooting with film, there are a finite number of photos you can take on a reel. This restriction helps to focus the mind and often the added pressure allows new creativity to blossom. Waiting for the film to be developed adds an air of mystery and excitement that will help your photography to stay fresh and passionate.

Top tip! When getting your photos developed, ask for the images to be put on a disk as well as printed in physical form. This way you can still edit and share your photos digitally.

LOW RESOLUTION

The digital world of photography is constantly developing and the quality and resolution of photos created by cameras continues to improve. However, creative, fun, and atmospheric images can also be created using a low-resolution camera.

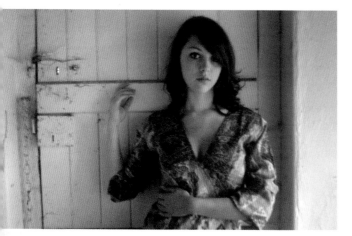

A low-resolution camera is an easy accessory to add to your toolkit. The cameras are cheap and usually very light. As most low-resolution cameras are also point and shoot, they are incredibly simple to master. When using a low-resolution camera, there is no need to spend time changing settings and lenses, and therefore it can be a good way to snap away at a model and to try out different poses, ideas, and expressions before focusing on a theme to shoot with your high-resolution camera.

Low-resolution cameras will produce a grainy effect that creates the feeling of a slightly vintage image. The colors will also often appear quite saturated. The low-resolution look makes the photo appear candid and intimate, as though it is from an old family photo album. When using a low-resolution camera, try setting the model in an everyday location and use natural, fake-candid (see page 22) poses to enhance this intimate feel. The grainy, saturated look can also be used effectively to create a fairytale feel, as the images will appear slightly unreal.

"The grainy, saturated look can also be used effectively to create a fairytale feel, as the images will appear slightly unreal."

+ Top tip! After shooting a model with your main camera, try taking a couple of snaps in the same pose with a low-resolution camera to add variety.

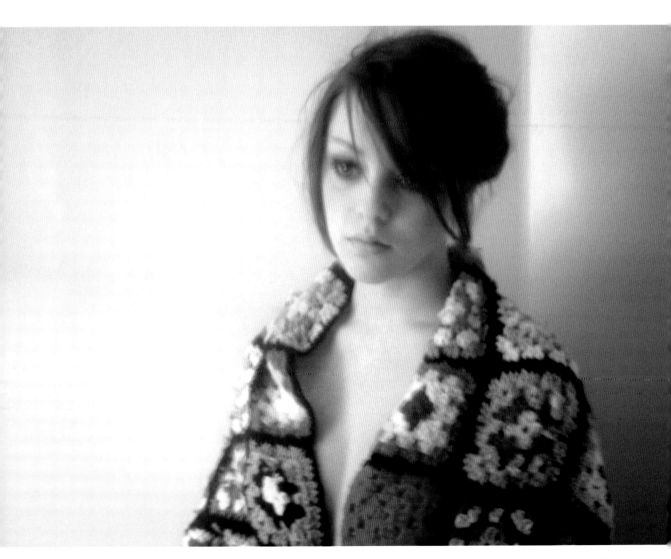

CHOOSING YOUR LENS

There are a wealth of lenses to choose from for your camera, all of which produce slightly different effects and better images in different contexts. It is worth taking some time to research which lens performs best in different settings before investing, so read reviews and ask photographers what has worked for them. Prices can also vary dramatically and increase the wider the aperture, so your choice will be affected by your budget.

"Take some time to research which lens performs best in different settings."

For portrait photography, it is generally considered that the 70–200mm, 50mm, and 85mm lenses perform best. With a cropped-sensor camera like an APS-C Canon Rebel, the 50mm *f*/1.8 lens works fantastically. The lens contours and slims the face slightly and allows you to be relatively close to the model while still having room for plenty of background. In practice, this close proximity makes it easy to communicate with the model, and shoot in smaller or busy spaces, and therefore is very useful and versatile for a wide range of shoots and locations.

With a full-frame sensor, the 85mm *f*/1.8 lens works brilliantly. It performs in a similar way to the 50mm on a cropped-sensor camera, contouring the face and allowing a crisp, in-focus image of the model with a beautiful bokeh in the background. With an 85mm lens, the photographer will usually need to be farther away from the model than with the 50mm, and that can prove problematic in smaller settings,. However, the beautiful bokeh created by the lens is definitely worth the issues with distance!

> ✚ **Top tip!** Cheaper, tried-and-tested lenses such as the "nifty fifty" (50mm) are usually the cheapest prime lenses available, so you should be able to find something to shoot your perfect portrait whatever your budget.

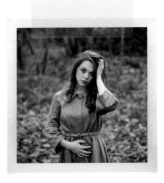

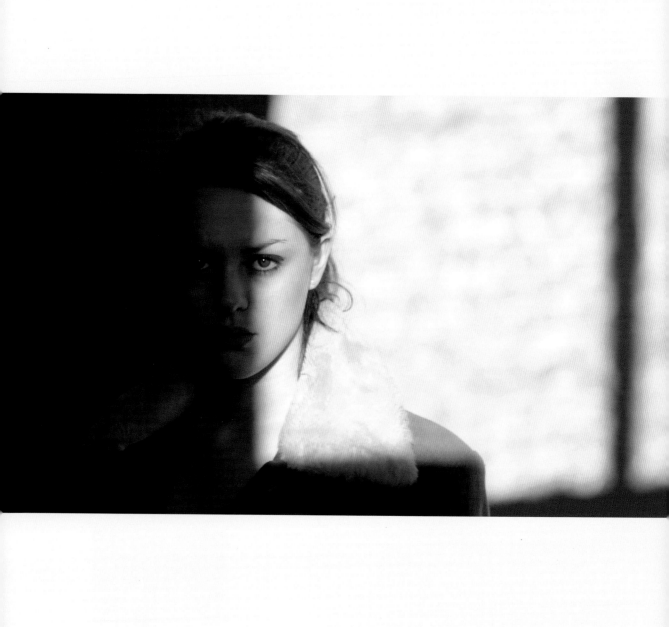

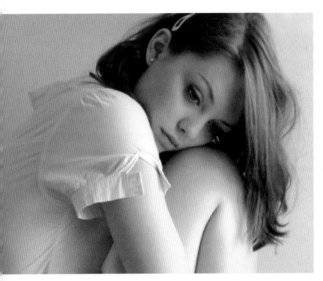
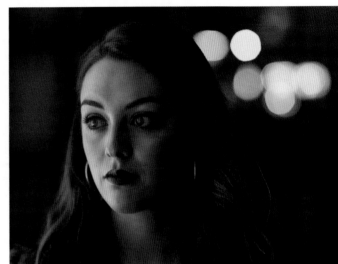

LIGHTING THE FACE | REFLECTORS | GOLDEN HOUR | SHADOW |
NIGHT PHOTOGRAPHY | SOFT LIGHT | HARD LIGHT | WINDOW LIGHT

LIGHT

LIGHTING THE FACE

When taking a portrait of a model, lighting the face correctly can make or break the shot. Good lighting helps to highlight a model's best features, provide shape and contour to the face, and also, when used creatively, to create mood and atmosphere. The following sections in this chapter will explore in more depth the various ways that the face can be lit using natural light, however, these pages will give an overview of some of the key ideas.

When working with natural light, it is important to take some time to observe what is happening with the light. Ask yourself where the light falls and what shapes and shadows are being made. Find where the light is channeling from, and move the model toward or away from this, to see the difference in how and where the light falls. It is useful to also move around the model to explore different angles and how it alters the light.

For a classically well-lit shot, turn the subject away from the light so the sun is behind the model. This will cast the face into shadow providing an even light across the skin. This is a classic and foolproof way to create a soft and well-lit portrait.

However, to add more character and shape to a shot, it is good to start experimenting with shadow. By adding shadow to the side of a model's face, you will create an enhanced feeling of depth, and it will also add to a more realistic depiction of shape and contour.

When working with a model, try to make sure that light is hitting the eyes. This will ensure that the model has a sparkle in their eye (called a catchlight) that will help draw the viewer into the picture and create a more immediate and impactful relationship. When working in natural settings, try to make sure there is something bright around, for example glass or a mirror, as this will reflect the light back into the model's eyes.

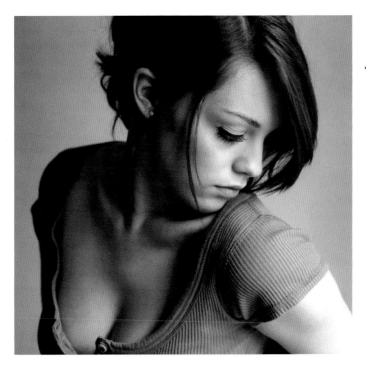

Top tip! A reflector is a really useful tool to help create beautiful lighting on a model's face. The reflector bounces light back up at the model, getting rid of any shadow. By using a reflector you are less likely to get the same contour and shape as when playing effectively with light and shadow, however it does provide a quick fix to create a well-lit portrait.

"It is useful to also move around the model to explore different angles and how they alter the light. "

REFLECTORS

One of the key elements to a great portrait is lighting. Illuminating the skin and highlighting the sparkle in a model's eye can transform your photo. Unfortunately, this can often prove problematic—particularly when working with natural light. A reflector is a fantastic addition to the photographer's toolkit that can help you to create a truly stunning image.

A reflector is a sheet of white, silver, or gold material or paper that, when placed in front of the model, will help to bounce light back onto the subject. Although it's useful to have an assistant with you when using a reflector, the model can hold the reflector for you in a pinch. When working with natural light, it is frequently preferable to put the model's face in the shade—this provides a lovely, even light, and also allows

"By moving the reflector around at different angles, you can bounce the light back to fill in any areas of the face which have a harsh shadow cast across them."

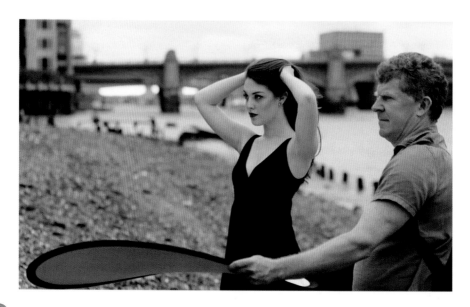

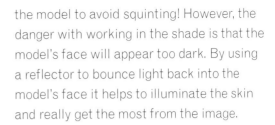

Top tip! You don't need to buy a reflector to get great results. A white bed sheet, white card, or tin foil can all be used to bounce light.

the model to avoid squinting! However, the danger with working in the shade is that the model's face will appear too dark. By using a reflector to bounce light back into the model's face it helps to illuminate the skin and really get the most from the image.

When working in harsh, bright light, the reflector can also be used to help provide an even light on the model's face. By moving the reflector around at different angles, you can bounce the light back to fill in any areas of the face which have a harsh shadow cast across them. Alternatively, the reflector can also double as a canopy of shade if you're in a particularly bright and exposed area.

The reflector is a simple, lightweight and fantastic tool to make sure you get the most from the natural light around you.

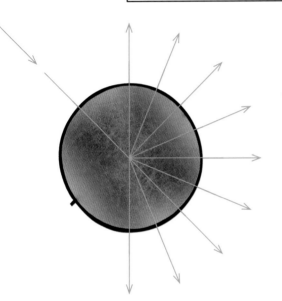

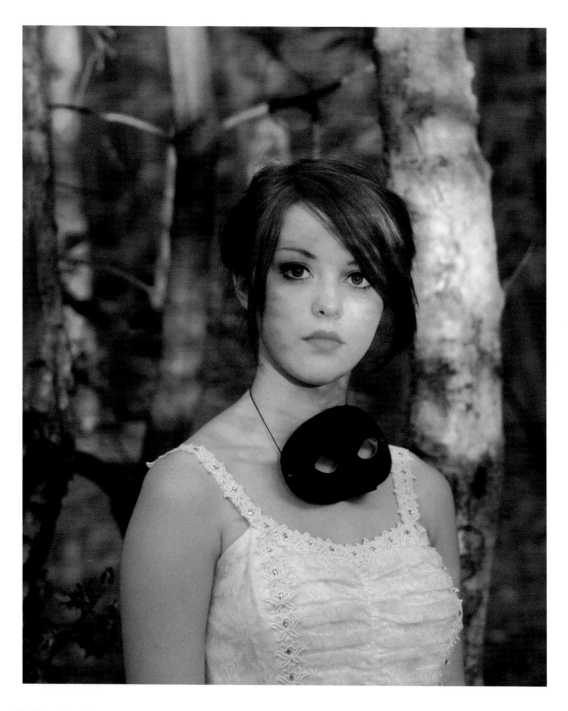

"The lighting is beautifully gentle, and creates a soft, magical feel to portraits."

GOLDEN HOUR

Golden hour is the time when the sun rises or just before it sets, and is one of the best times to take natural-light photography. The light during this time is beautifully gentle, even, and diffused and creates a soft, magical feel to portraits—almost as though the model is within a hazy dream. As the light has a lush, diffused quality, it provides an even wash over the model's face. This makes the skin appear soft, warm, and evenly lit, without the need for fill light.

A particularly beautiful effect when shooting during the golden hour is to place the model in front of the sunlight so the warm light highlights the model's hair. The light can be used to highlight the hair with

+ Top tip! Try experimenting with the model's position in relation to the light. As the light is softer during the golden hour, the model is often able to look directly into the light, for an even wash of light, without squinting. You can also feature the golden, warm light from the sun in the background for a really beautiful effect.

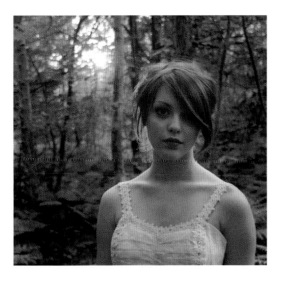

a beautiful halo effect, or alternatively, as in the image on the left, the soft, orange glow can shine through the hair to create a warm, enchanting feel. Golden-hour photography looks particularly beautiful for photoshoots in woodlands, parks, or other natural settings. The canopy of leaves or trees will diffuse the light further, creating a magical dappled effect.

SHADOW

When shooting in natural light, it can sometimes be difficult to create a soft, even light on the model's face. Strong sunlight, although beautiful, can eat into the colors of the face and create a burned-out look. To create a softer image with even lighting and tones, try placing the model in shadow.

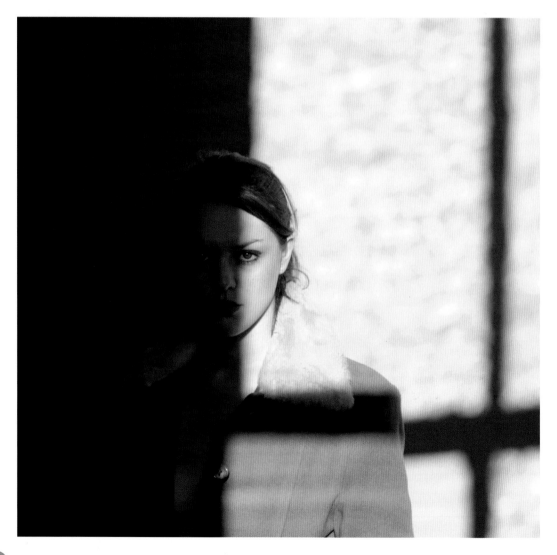

> **Top tip!** When shooting in low light, it can be a challenge to focus. Try using a tripod to steady the camera and ask the model to stay as still as they can.

When shooting outdoors, you can place the model in shadow by asking them to face away from the sun or source of light. The light behind can still be used to shine through and highlight the hair and other elements of the picture while the light across the face will appear soft and even, creating a more appealing look.

In interior shots, the same principle of moving the face away from the light source applies. Consider where the light is shining through the window, and angle the model's body so that they are facing away from the light source. Although facing away from the light, the model's eyes will still often pick up the light in the room, as they are slightly glossy. This will help the eyes to shimmer and pop while the face still remains beautifully even.

By shooting in a darker, more shadowy setting, you can create a melancholy or sinister feel. Manipulating the light and shadow so that half of the face is concealed, and half is in light can create a darker, more emotive image. Using the harsh lines of shadow from windows or objects can also create a cinematic effect, as in the image opposite.

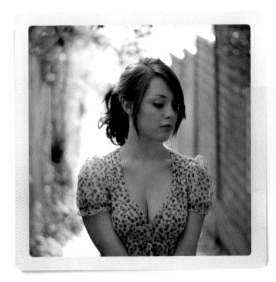

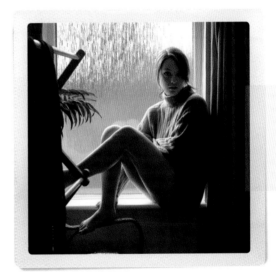

"Consider where the light is shining through the window, and angle the model's body so that they are facing away from the light source."

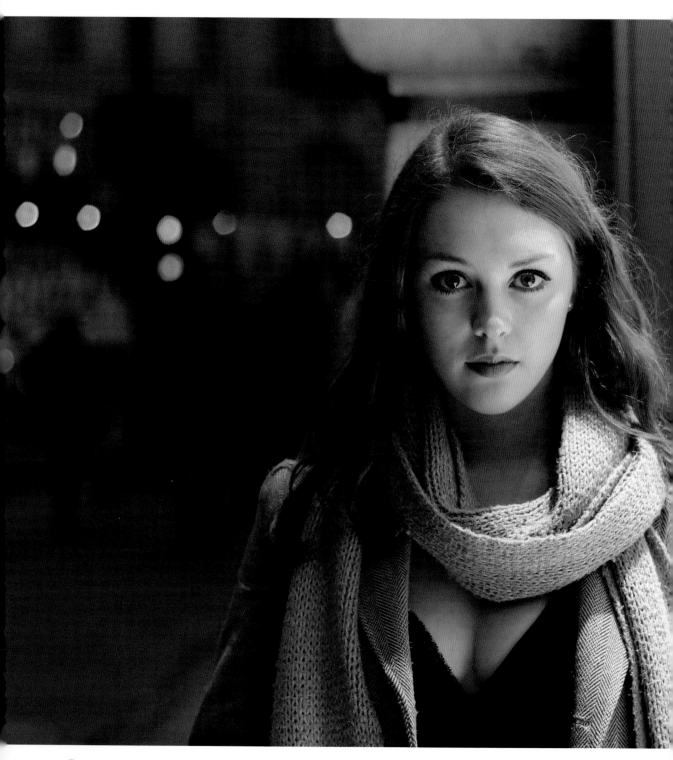

NIGHT PHOTOGRAPHY

It is often easy to feel like photo shoots need to end as the light dips at the end of the day. However, you can still take beautiful photos at nighttime. In fact, most cameras today are designed to handle low-light situations with relative ease. Head to a town or city as the light begins to drop and make use of the light from cars, lamps, and shop windows.

When out at night, light from shop fronts can be used to illuminate the model's face. By placing the model to the side of the shop front and turning their face slightly toward the light, you can still shoot a well-lit portrait at night. Alternatively, try placing the model facing the artificial light for a flatter, even light.

+ **Top tip!** Pack a small, handheld light with you to help illuminate areas of the model's face that need some extra light.

When shooting in low light, it is helpful to keep posing very simple. Slightly changing the angle of the model's face can change the look without adding too many focus complications. For example, looking up into the light can capture the face in a different way and works very effectively to make the most of the light that is available. By bringing the hands up to the face you can add extra interest into your images.

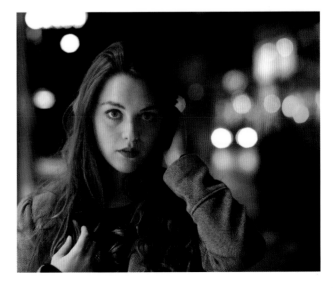

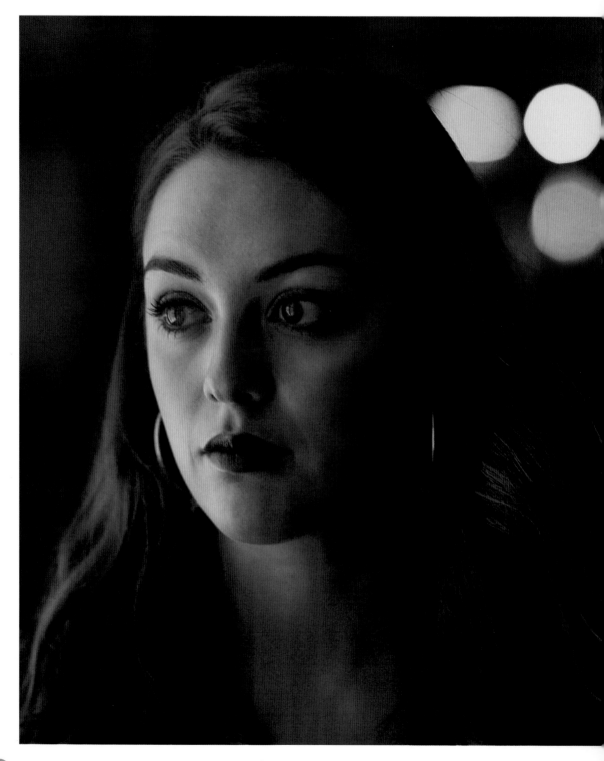

Night photography looks particularly magical when using a shallow depth of field. The bokeh in the background will make the car and street lamps blur into beautiful colored orbs of light. Shop fronts and their lights often provide fantastic ways to find different colors and hues of light which can be used to create a colored-filter effect and a different look to simple portraits. You can also use color to manipulate mood in your photos. For example, a blue light can be used to suggest a melancholy feel to your image. In addition, shop fronts can work beautifully to add reflections to your night image. The glass will pick up surrounding light and reflect it back, adding extra light to the image and also making the most of the variety of colors. You can also use glass to reflect back the model's face for an interesting look.

When working in low light, increasing the ISO will also help to utilize as much of the ambient light as possible. Decreasing the shutter speed can also help to create a clear picture at night. Working with a high ISO or low shutter speed, however, can cause problems with camera shake and make it more difficult to focus. If you are shooting somewhere that is less busy or where it will not be too intrusive, using a tripod can help steady the camera to create a sharp image. Ledges and surfaces naturally available within your surroundings can also be used to steady the camera by resting the camera on the surface. If you need to be more mobile for your shoot, make sure to tuck your elbows tightly into your body to steady your hands as much as possible.

"Shop fronts and their lights often provide different colors and hues of light which can be used to create a colored-filter effect."

SOFT LIGHT

Soft, natural light is some of the most effective for creating a beautiful, relaxed portrait. Soft light is created by having an even light source that is not directly channeled towards the model, but is instead traveling across the model's face in a diffused way. The effect is an even wash of light that illuminates the model's face. The soft light will create a smooth gradation between light and shadow for a flattering, beautiful image.

To create soft light across the model's face, try to make sure that the model isn't directly in front of a light source. This will allow the light to softly diffuse across the skin. When working with natural light you can achieve this by turning the model away from the sun, or placing the model next to a window that doesn't directly face the sunlight. Although turning the model away from the sun, you will still need to be aware of the direction of the light source and to use this effectively in your photo. For example, if the soft light is traveling from the side of the model, you can use it to good effect to highlight one side of the model's face and leave the opposite side in shadow. As the light is soft, the result will be less dramatic than in strong light and will allow for a gentle, flattering contour to occur.

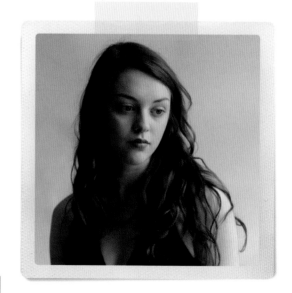

Top tip! If you are working with strong natural light indoors, try using netting over a window to gently diffuse the light.

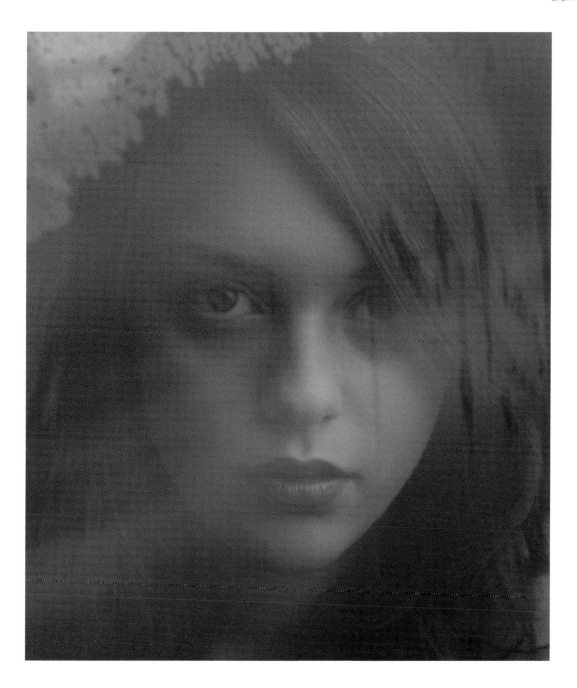

"The soft light will create a smooth
gradation between light and shadow
for a flattering, beautiful image."

HARD LIGHT

Hard light is created by placing the model in front of a strong, directional light source. This creates a defined gradation between light and shadow as the light hits the subject. Generally in portrait photography, the most beautiful images are created by using soft light (see page 76) however hard light can be used to a striking, dramatic effect.

As the light source is strong and directional, a small portion of the face will be highlighted and defined areas, or stripes of shadow will appear. These strong areas of shadow can be used to create a cinematic or film noir feel. The shadow will leave some of the face partially obscured and therefore create a sense of intrigue for the viewer. By creating a generally darker mood to your photo using a sinister setting or darker clothing you can amplify a sense of storytelling.

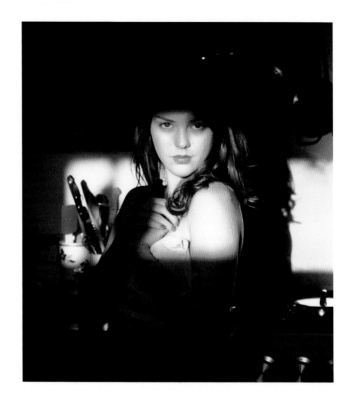

Where the light hits, hard light will tend to highlight all the features and textures of the model's face and surroundings. This can in many cases create a less flattering image, however it can be used effectively to create a very intimate and real image as well. If focusing on textures, try converting to black and white (see page 104) to emphasize this quality.

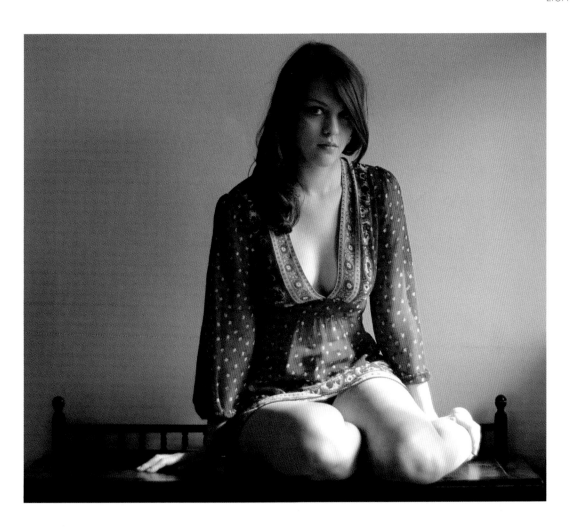

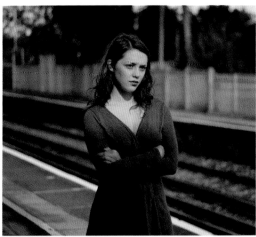

+ **Top tip!** If you wish to create a dramatic effect in your photography and you are working on an overcast day without strong, directional light, try experimenting with an artificial light or flash."

"Hard light can be used to a striking, dramatic effect."

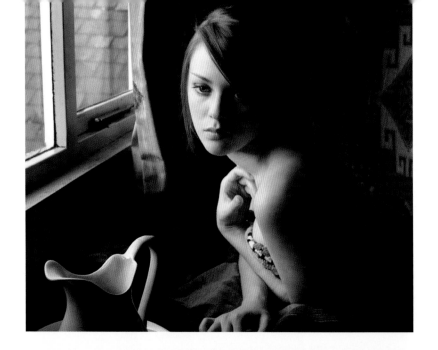

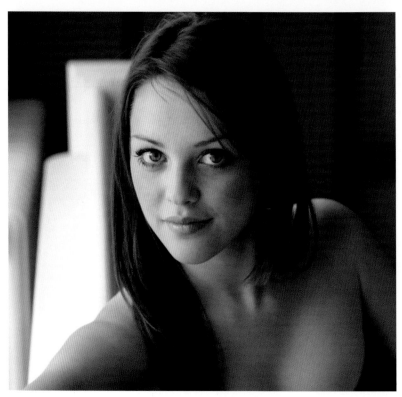

"At different times of day, you will also get a different color and strength of light."

WINDOW LIGHT

Window light is a simple and effective natural light source that provides easily controlled, directional light.

To change the light available, move the model along the window to explore the brighter and softer areas. Moving the model toward and away from the window will also modify the amount of light and shadow available to you. You can create a soft and even light by moving the model farther away from the window and turning them to face the glass. At different times of day, you will also get a different color and strength of light. Try taking a photo of the same spot in your house over the course of the day and see how the light changes. You can then incorporate this into your photoshoots.

The light from a window can often be used to its best and most beautiful effect when the model is placed to the side of the window. The light channeling in from one side will highlight the side of the face nearest to the window and cast the farther side into shadow. This creates a wonderful sense of depth and contour to the face. The light entering from one side will also catch the natural highlights in the model's hair and can add a beautiful, soft halo effect. If the light is proving to be too strong, a net curtain will diffuse it beautifully.

+ Top tip! As well as providing beautiful natural light, windows can make a wonderful frame and architectural feature in themselves. Place the model close to the window and include some of the frame to surround the model and draw the eye into the focal point of the image.

As well as the natural light available, you can also use shadow from the window. Placing the model near the window and in part obscured by shadow or in silhouette can create a wistful effect with an air of mystery. If the light is particularly strong, you can also create a cinematic look by allowing the window frame to cast strong shadows across the face. It can be difficult to capture this in color, so try changing the photo to black and white. To provide an extra level of story to your image, ask the model to stare out toward the window, drawing the viewer's eye along with them.

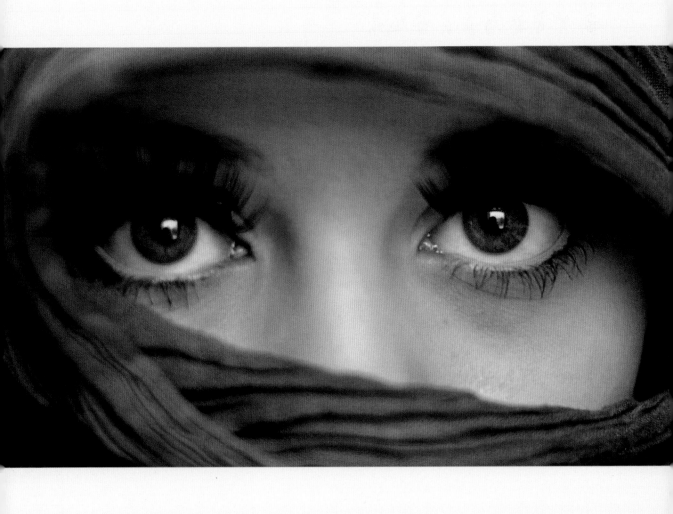

TAKING YOUR SHOT

PICKING YOUR BACKGROUND | BOKEH | COLOR MATCHING |

LEADING LINES | RULE OF THIRDS | FREE LENSING | SHOOT THROUGH GLASS |

FOREGROUND FRAMES | CONVERT TO BLACK & WHITE | EYES

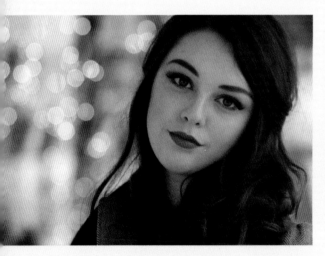

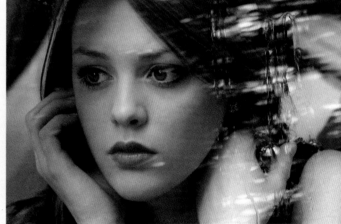

PICKING YOUR BACKGROUND

The background to your photograph is fundamental in creating a well-composed and striking image, but can easily be forgotten when directing a model on a shoot. A distracting, cluttered, or jarring background can sadly ruin an otherwise good photo so it deserves careful attention both before and during the shoot. A background can help to tell a story, and therefore it is important to plan ahead and pick a background that adds to the image you are creating.

An easy way to create a visually cohesive background is by keeping it simple and uncluttered. This will allow the model to be the central point of the image without any distraction. However, even with a plain background it is important to consider how the background can integrate with what the model is doing in the foreground. An easy way to create a relationship between the two is by including complementary colors or an element of color matching (see page 90). This will draw the two together and create a strong, well-composed image.

To make the model stand out, a plain but contrasting color for the background can help the subject to visually pop. Shallow depth of field and background blur will also help to make the model stand out from the

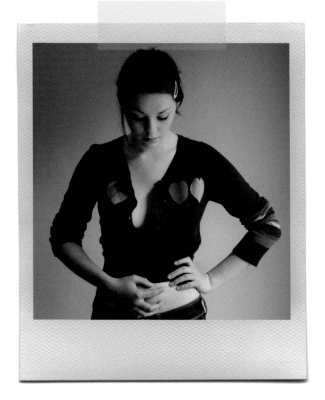

+ **Top tip!** If trying to create a studio feel for a portrait at home, a roll of plain colored paper or cardboard in white or gray can be placed behind the model for an effective plain background.

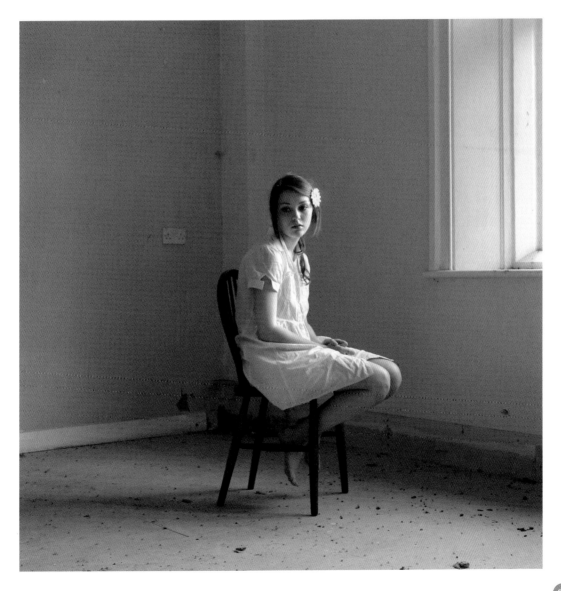

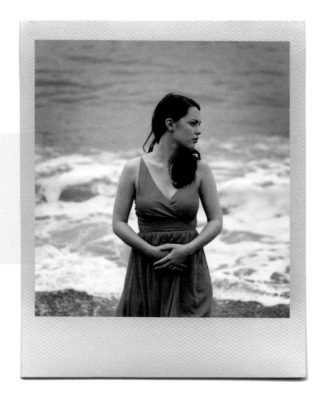

"Cities and towns provide a busy, urban feel whereas woodland or outdoor settings with trees and flowers will create a softer, natural look."

background by creating visual contrast. By blurring the background, the viewer can still create an impression of the surroundings, providing context and story, but the eye is less likely to be distracted and can focus on the main subject.

Deciding on a visual theme or emotion for your shoot can also help in choosing a background. Cities and towns provide a busy, urban feel whereas woodland or outdoor settings with trees and flowers will create a softer, natural look. A model also doesn't have to always be placed directly in the forefront of the image. Using foreground frames (see page 102) that incorporate elements of the background in front of

and surrounding the model can be a fantastic way for both to work in harmony with one another and feel truly integrated.

When shooting, consider the distance between your subject and the background. If you are using a busier background to help tell a story, try placing the model at a distance from the background. This will create the effect of the model being more visually separate from the surroundings and therefore the eye will be more easily drawn to the subject of the image.

When out on a shoot watch out for busy cluttered backgrounds, objects coming out of the subjects head and clashing colors.

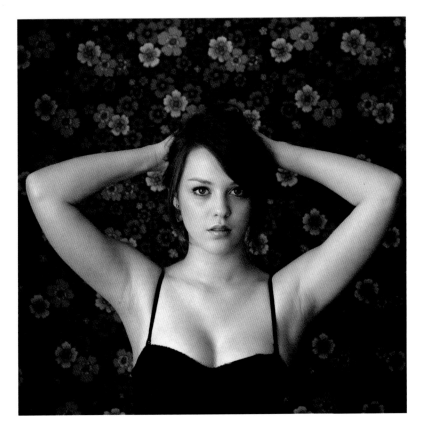

These will distract the viewer and create a visually jarring image. If you cannot avoid a visually distracting background in your image try getting in close (see page 114) and filling the whole frame with your image. Alternatively, in post-processing, try cropping your image to eliminate busy and cluttered areas.

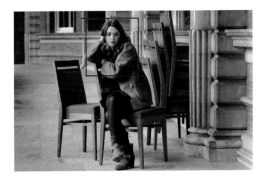

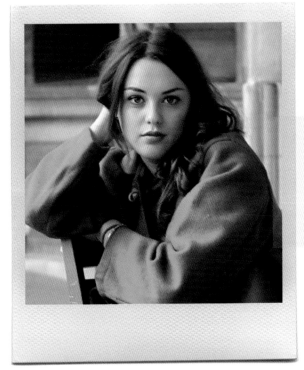

BOKEH

Bokeh refers to the quality of the out-of-focus sections of a photograph. It is used to describe the blurred sections and hazy shapes that appear in the background or foreground of images. When done well, these are soft and appealing to the eye, and the out-of-focus layers alongside the sharp focal point of the image will help to create a sense of depth.

Not only does the bokeh itself look beautiful, it also helps to draw attention to the subject of the image as the eye will naturally be drawn to the part of the image that is in focus. The background will become more of a wash with an impression of shapes and colors rather than distinct objects. This will be less distracting to the eye and allow the subject to pop out of the image. Bokeh, therefore, can be used to great effect in portrait photography where the model is the true focal point of the image.

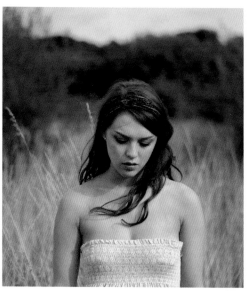

Using lights—whether candle light, artificial light, or sunlight through trees—creates a wonderful blurred effect in the background of portraits. Lights will often create sparkling, hazy orbs in the background of your photo that are particularly visually appealing. It is worth taking advantage of the colored lights available at festival times such as Christmas to create a fun, themed shot.

Consider the colors in the background to make sure that the haze works in a visually appealing way. Woodland and trees are particularly effective as the greens and browns work cohesively together.

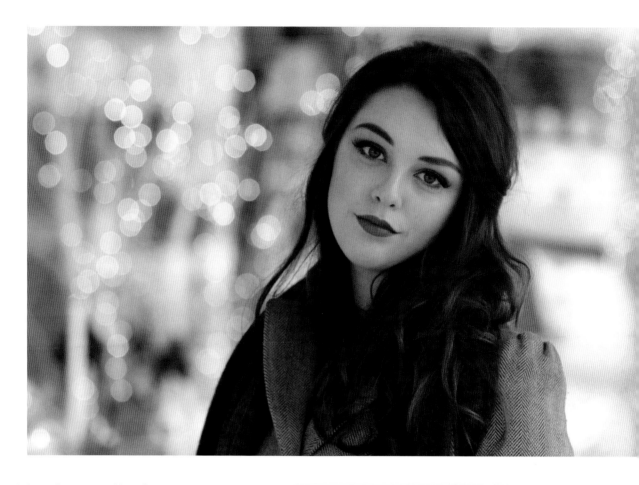

"Lights will often create sparkling, hazy orbs in the background of your photo that are particularly visually appealing."

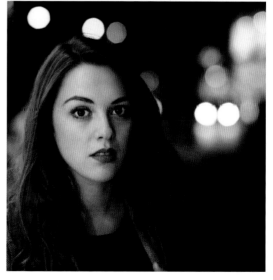

+ **Top tip!** Try shooting in a town or city at night and make use of the lights from cars and street lamps for beautiful colored bokeh.

COLOR MATCHING

Color matching is a simple way to create a strong and cohesive image and doesn't require any fancy or expensive equipment. By adding a few elements of the same color or shade to a photo it instantly makes it look well composed and thought through.

When color matching in your photography, preparation is key! In order to match the colors, you need to know where you are shooting and how you are going to incorporate the colors. If you are shooting in an area with a particularly prevalent color (e.g., green in woodland) you may want to pack accessories to match with these colors. In a studio or home setting, you can use clothing, makeup, accessories, and props to match colors. Props can help to tie into a background or can become the starting point to your color-matched image.

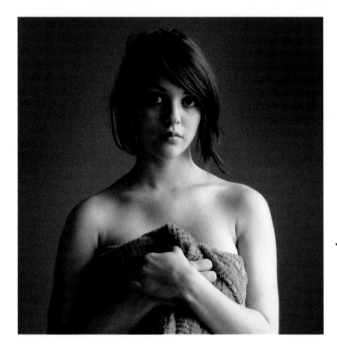

Top tip! To create a really strong, cohesive image, try to incorporate at least three elements of the same color.

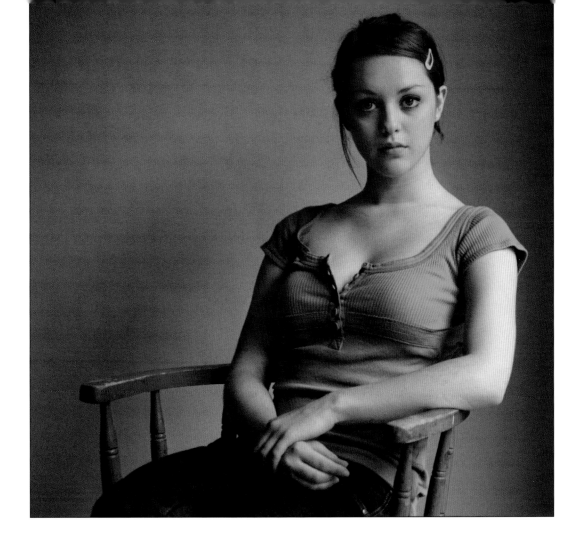

You can also use a model's eyes as the inspiration for your color-matched image. For example, in the photo above, green clothing, accessories, and props have been used to match with the eye color. In post-processing, the color of the eyes was then enhanced to strengthen the natural pop of green.

If you don't want to use a vibrant color, try matching similar hues and tones. Shades of gray, beige, and brown can also work more subtly to create the same effect.

"Props can help to tie into a background or can become the starting point to your color-matched image."

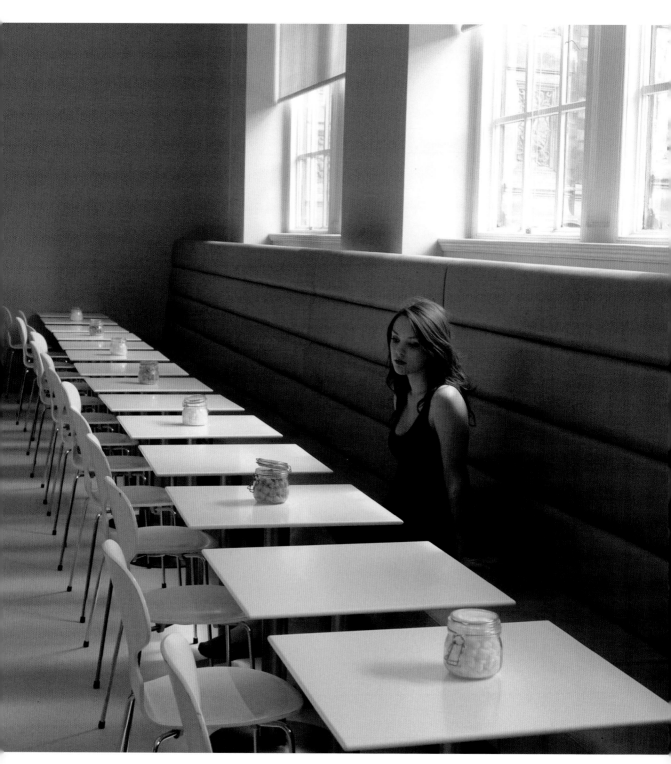

LEADING LINES

Leading lines travel through an image and head toward a distance point in the photograph. By placing a model in the middle or at the end of a leading line, the eye will move along the line to the focal point of the image. Using leading lines is a strong way to make the model feel cohesive with the surroundings and background when working in natural settings.

Leading lines work most effectively when they travel toward the center of an image. This not only draws the eye into the photograph but also helps to create a feeling of depth. Consider where you want the central point to be and use your leading line to draw the eye toward it—creating a directional pull and an enhanced feeling of space and distance within the image. By choosing where your leading line travels, you can manipulate and guide a viewer's eye so it is drawn to the point you wish to highlight within a more complex scene.

> "By choosing where your leading line travels you can manipulate and guide a viewer's eye."

One of the strengths of leading lines in composition is that they invite the eye to travel through the image. By suggesting this travel, straight lines work particularly effectively to enhance this effect. Shooting with a model on a road or by the side of a train track creates a feeling of movement from the leading line and implies a sense of journeying somewhere from the line itself. This can be used to add an extra element of storytelling to your image. (Note: Never photograph on an actual train track unless you have the proper license/permission.)

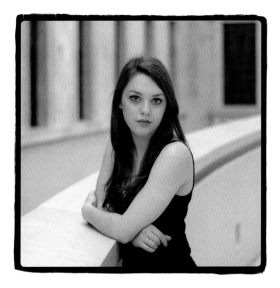

"Using a leading line helps
to pull the eye into the image
and to travel along the line
to the point where the model
is placed."

Corners also provide a simple and strong way to draw the eye into the center of the image. The two diagonal lines draw in the eye to the central point. By placing the model in the corner, both lines are used to create a strong pull into where the model is placed. In the examples here, you can see how using leading lines helps to pull the eye into the image and to travel along the line to the point where the model is placed.

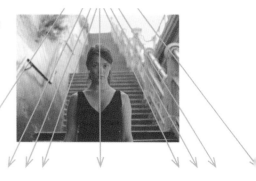

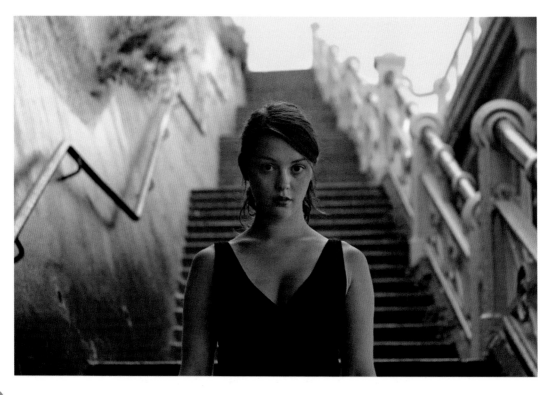

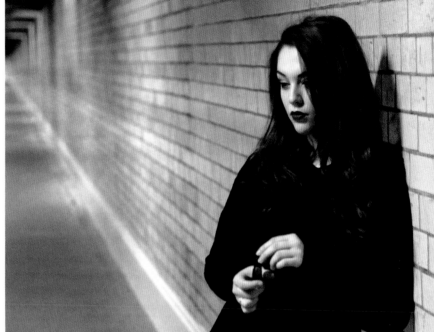

You can find leading lines almost everywhere—from walls to train platforms, staircases, and benches. When you've found your leading line, try experimenting with where the model is placed and how they are posing. You can create a lonely or vulnerable feel by placing the model far away along the line or by using a seated or crouched position.

Some examples of natural and manmade objects and elements that can work effectively within your photography are roads, train tracks, rivers, trees, railings, bridges, walls, buildings, and windows. Wherever you are shooting, it is worth taking time to assess where natural lines appear so you can use them within your image.

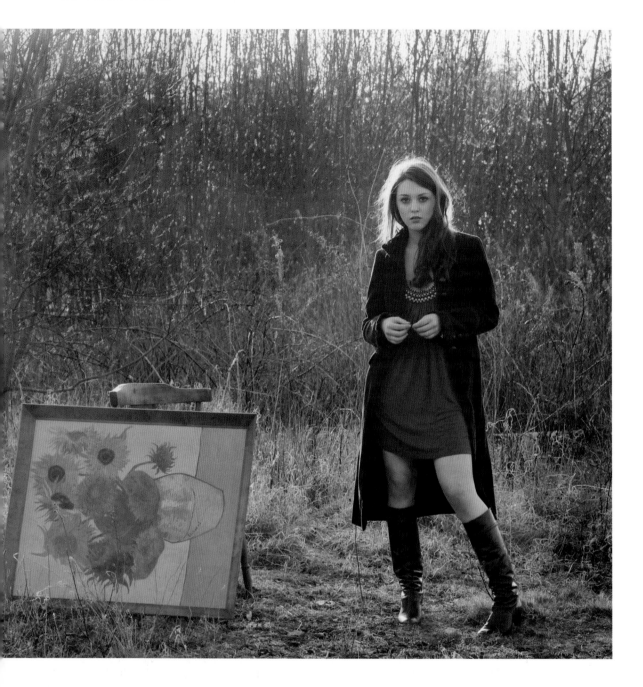

"For really strong composition, place the focal
point of the image on one of the points where
the horizontal and vertical lines meet."

RULE OF THIRDS

The rule of thirds is one of the best-known rules of composition for photography. The basic principle is that the image should be split into a grid of nine squares with two horizontal and two vertical lines. The photo should be composed using the lines of the grid as reference points for where to place both the focal point of the image and the background. Many cameras will feature the grid on the screen to help, but it is good practice to try to keep it in your minds eye at all times.

For really strong composition, place the focal point of the image on one of the points where the horizontal and vertical lines meet. For example, when shooting with a model, it is good to place the eyes on one of the meeting points in the top third of the photo. This will draw the viewer to the model's eyes for a really intimate and arresting image, and will also allow the rest of the model's face and some or all of the body to be featured in the bottom two thirds of the image.

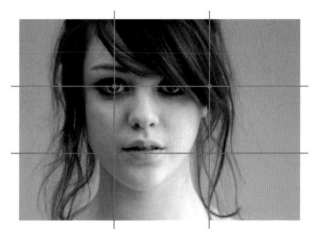

Consider where to place the background within the grid. Horizon lines look particularly effective in the top third of the image, allowing space for the scene below. It is also effective to leave blank space in one third of the picture. This will encourage the viewer to focus on the model or central object in the image without being too distracted by visual noise.

+ **Top tip!** If you have a photo that isn't quite working compositionally, try cropping in post-processing so the eyes line up with one of the points where the horizontal and vertical lines cross. This can completely transform and thereby save an image.

FREE LENSING

Free lensing is a fun technique to create a soft, out-of-focus look to your portraits with plenty of bokeh. The effect is created by removing the lens from the camera and tilting it to modify the amount and location of the blur. You'll create an image with a dreamy, otherworldly quality and with a vintage feel.

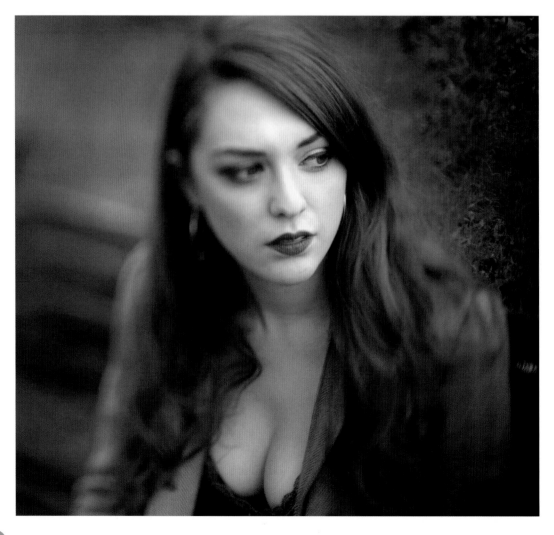

Top tip! As focusing is a challenge with free lensing, ask your model to wear a simple outfit and pick an easy pose so you can concentrate on your camera.

Before you remove the lens, set the camera to manual focus, a wide aperture, and the focal length to infinity. Next, remove the lens from the camera and start tilting up and down and left and right until you are able to focus on your model with a beautiful soft-blur surrounding. It is advisable to use a small lens such as the 50mm while free lensing, as it weighs less and will be easier to hold and support with your hand.

When shooting a portrait, by tilting the lens from left to right, you can shift the blur to either side of the image. This works particularly effectively if you are placing the model on one side of the photo and want a beautiful bokeh effect fading out to the other side.

"You'll create an image with a dreamy, otherworldly quality and with a vintage feel."

Free lensing does take patience as it can take time and persistence to perfect and get the model's face in focus. You shouldn't expect to create a crisp, sharp portrait, but instead, to focus on the light leaks and intense bokeh to create something interesting and different. If you have been shooting with a model for a while it is a great way to add an alternative look to your portfolio.

SHOOT THROUGH GLASS

Shooting a portrait through glass is a fantastic storytelling technique in portrait photography. It requires determination to create the perfect result, particularly as glass can often have dirty smudges and will frequently reflect back dappled patches of light; but when taken well, it creates a fantastically interesting and emotive portrait.

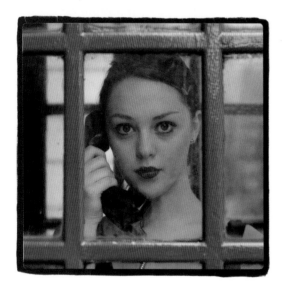

One of the wonderful things about shooting through glass is the cinematic, atmospheric look that can be created. By placing glass between the model and the photographer, an extra distancing effect is created that makes the model appear removed from the viewer and provides a more candid look.

Another advantage to shooting through glass is the readymade frame that is provided for your photograph. When shooting through a car or house window, include some of the window frame in the photo to give the photo context and shape. Having a frame helps to draw the viewer's eye into the photo and to focus in on the model or subject.

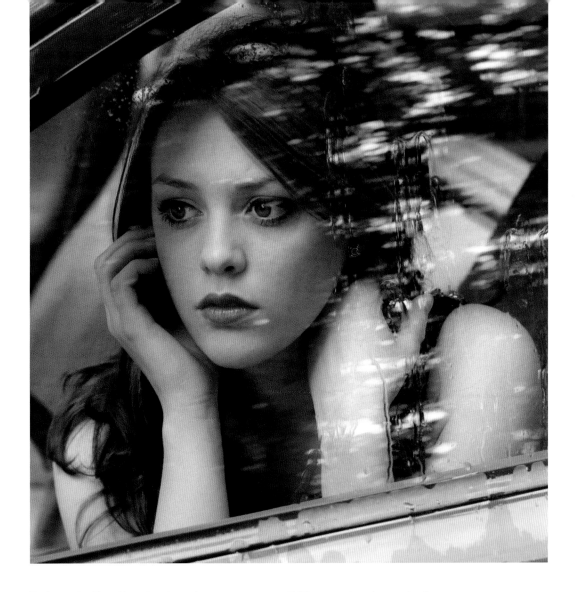

Before starting the shoot, make sure you have prepared the model and talked through the photos you will be taking. Once you are on the other side of the glass, it will be hard to hear one another and therefore it is important that the model knows what you want to achieve and that you have put in place some simple hand signals so you can communicate without sound. This will make the process quicker and easier for you both.

"Dappled patches of light can create a fantastically interesting and emotive portrait."

Top tip! Try pouring a little water on the glass to create a feeling of rain and a more textured, cinematic look.

FOREGROUND FRAMES

Any photograph naturally frames itself due to the parameters of the image on a screen or on paper; however, by adding an extra frame within the image it helps to draw the viewer's eyes into the main subject of the picture.

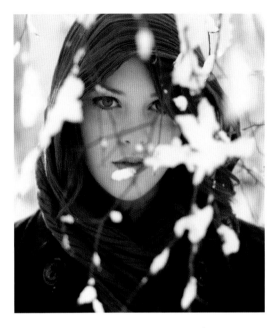
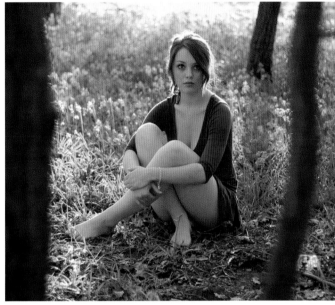

A foreground frame is where framing is created by an out-of-focus or blurred object or objects in the foreground of the photo that loosely frames the main subject behind. The technique happens frequently in cinematography and creates a more candid feel, as though the viewer is really there and looking in on a scene.

Natural landscapes work very effectively for foreground frames. Trees, branches, and leaves in the foreground of an image all create a beautiful blurred frame and are very easy to make look organic within a photograph. When shooting in woodland, as in the examples above, try placing the model between tree trunks and branches for a strong foreground frame. This will also give a sense of depth to the image.

Foreground framing also works very effectively when shooting on the street and in crowds. By placing the model still in the middle of a crowd and allowing the people surrounding to swarm around out of focus you can create a strong look. This setting is often particularly emotive as the model is static amid a swarm of moving bodies.

+ Top tip! When using a busy foreground frame, for example in a crowd scene, ask the model to stare directly into the camera. This helps emphasize the difference between the static model the movement all around and creates an intense and arresting image.

CONVERT TO BLACK & WHITE

Black and white photography has always held a visual magic. The variation of white, gray, and black shades creates a soft, romantic, and beautifully deep picture with a timeless, classic feel. The layers of gray invite the viewer to imaginatively fill in elements of color and texture, engaging their inner artistic eye. Many of the greatest photographers still choose to shoot in black and white and the iconic look proves to be enormously striking and popular.

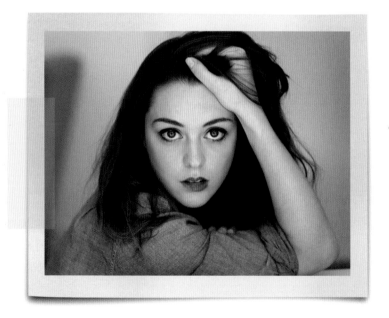

+ Top tip! Before discarding a color image you are unhappy with, try converting to black and white to see if you can find new life and interesting tones in the image.

Black and white helps to highlight contrasts in shade and light within an image. The layers of gray create a wonderful depth and help to highlight areas of light and shadow. When using a model's eyes as a central feature of an image, a change to black and white allows the whites of the eyes to pop out and sparkle, drawing the viewer's eye to them.

If you have a very busy and colorful background that appears too distracting and jarring, converting to black and white can also help to save your image. It will tone down the visual distractions and can help to make the model pop out of the image in the foreground. Equally if you find that there are clashing colors in your image then a change to black and white can help to eradicate the issues and save an otherwise troublesome picture.

"A change to black and white allows the whites of the eyes to pop out and sparkle, drawing the viewer's eye to them."

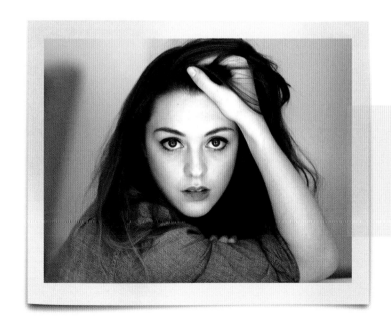

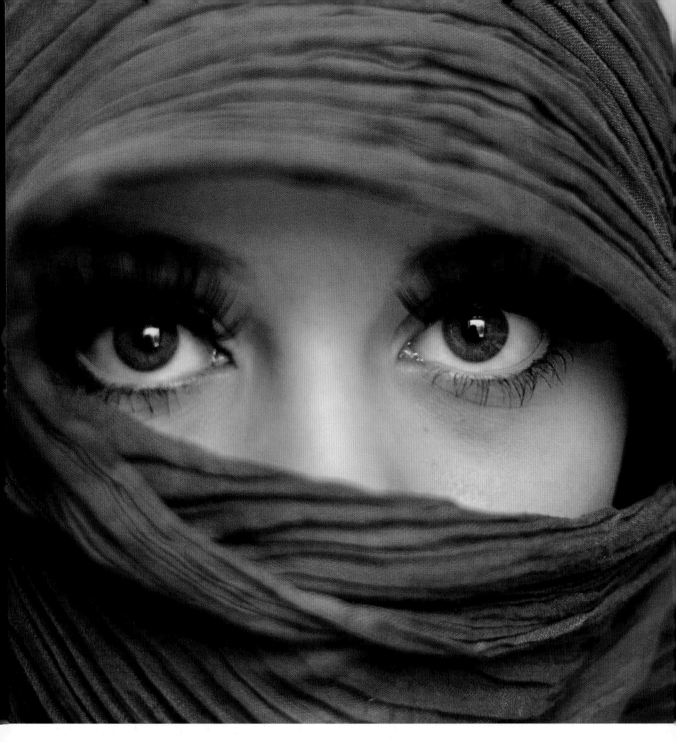

"Eyes can be a fantastic way to create
a really intimate and emotionally striking
image that tells a personal story."

EYES

It is often said that the eyes are the windows the soul. When photographing a model, the eyes can convey a mood or begin to tell a story, even when the set up is very simple.

+ **Top tip!** To enhance the feeling of the eyes being a central point to the image, try incorporating objects and accessories that color match with the color of the model's eyes.

In portrait photography, it is important to make sure that the eyes are strongly in focus. This will give an immediacy to the image and will create a real sense of personal connection with the model. A model's eyes can express a huge range of emotion without needing to change much of the expression on the rest of the face. Asking the model to convey sadness or happiness through their eyes can be a fantastic way to create a really intimate and emotionally striking image that tells a personal story. Asking the model to bring

their arms up towards the face is a great way to use soft leading lines (see page 92) to draw the viewer's gaze to the eyes.

To make the eyes appear bigger, ask the model to tilt their chin downward. This will force them to look upwards into the camera and widen their eyes. To enhance this effect further, place the camera above the model. A slight downwards slant will once again make the model look up towards the camera, making the eyes appear larger.

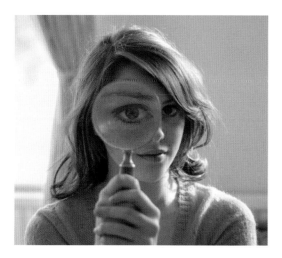

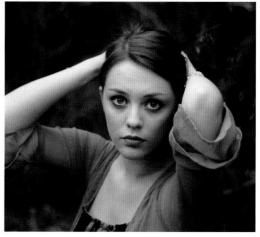

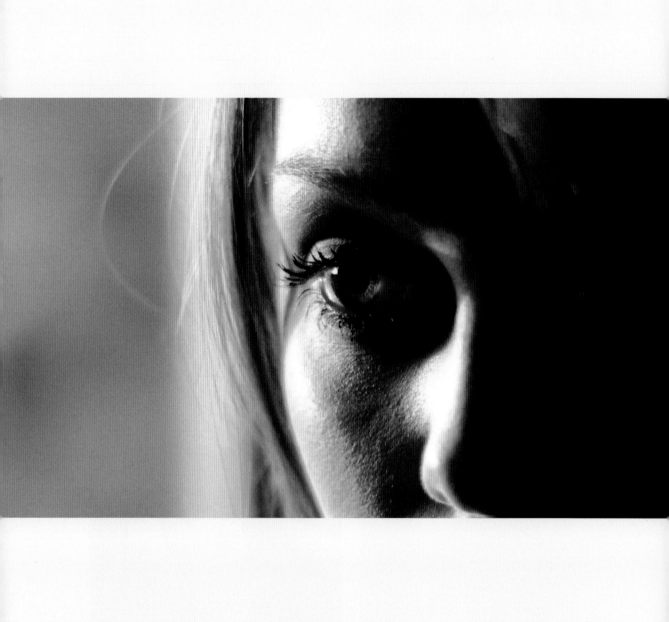

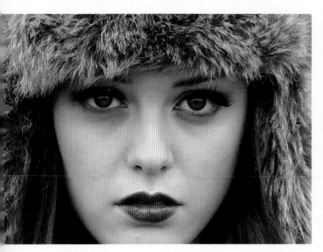
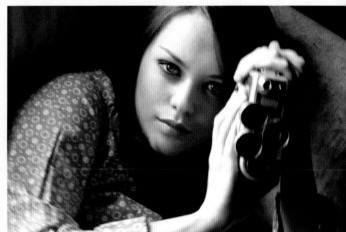

SHOOT AT 45 DEGREES | STRAIGHT ON | GET IN CLOSE | UNUSUAL ANGLES | SHOOT AT A SLANT

ANGLES

SHOOT AT 45 DEGREES

Photographs of people are often most flattering when taken from above. A downward-pointing angle of 45 degrees helps to slim down the face and also makes the eyes appear wider and larger.

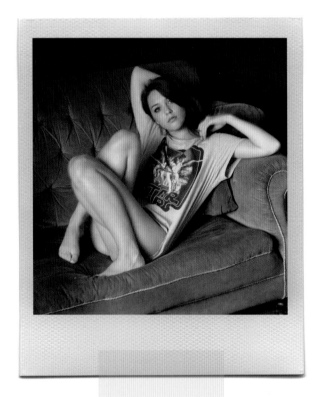

If you place the camera at too high an angle, a model's features may become distorted and they will be more likely to raise their eyebrows or strain to look at the camera, creating wrinkles on the forehead and a less relaxed look. Shooting at a softer 45-degree angle gives you one of the most flattering and consistently successful viewpoints for beautiful portrait shots.

Top tip! If you are packing light for a shoot, ask the model to kneel down to get high enough for the 45-degree angle. If you are taking a head-and-shoulders portrait, the photo will still give the impression that the model is standing.

On a shoot it is helpful to pack a stool or a ladder so you can get above the model for the 45-degree shot. Hills and steps can also be useful tools to help you get a high enough angle above the model. If taking a full body shot, ask the model to sit down. Adding the legs into the shot can add an extra level of interest through the different shapes and angles created.

"Shooting at a 45-degree angle gives you one of the most flattering viewpoints for beautiful portrait shots."

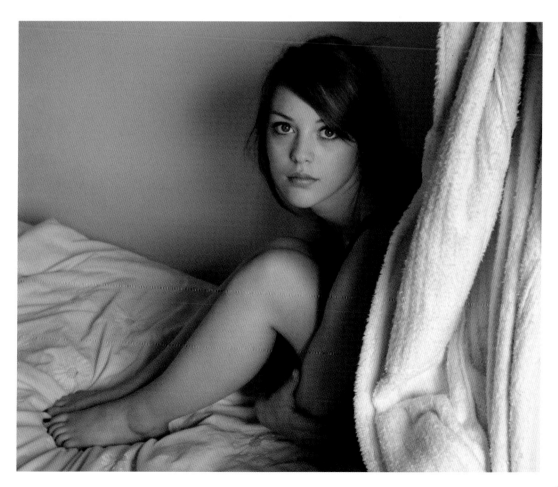

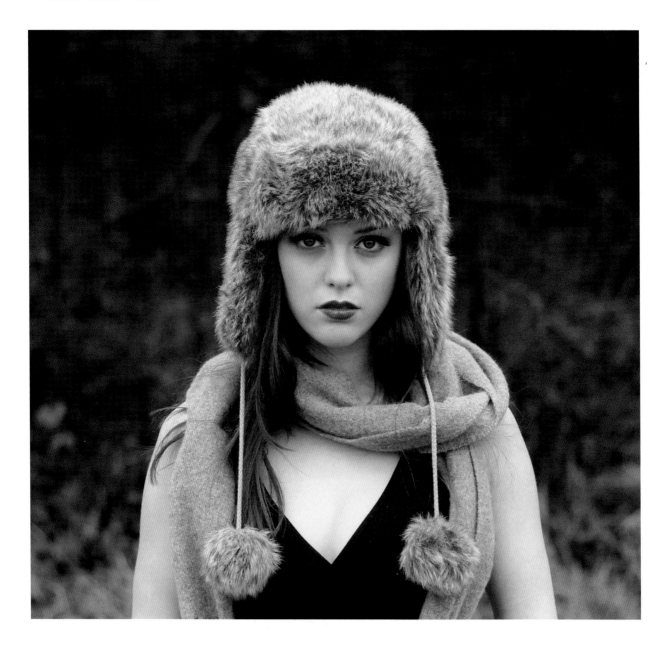

"When a viewer looks straight on to a model there is an immediate sense of contact and impact."

STRAIGHT ON

In everyday life we often choose to face someone straight on when we are trying to create the most immediate impact and engagement. By making sure we meet someone's gaze on a level with our own, we push for interaction with another. The same applies in portrait photography. Although many beautiful and emotive photos can be created by altering the angle of the camera, by shooting straight on, there is a certain immediacy to the image that works fantastically well for portraits.

When a viewer looks straight on to a model there is an immediate sense of contact and impact. The viewer will be particularly drawn to the model's eyes that are often the most beautiful and emotive part of an image. This can then encourage the viewer to have a more personal and emotional connection with your photography.

When composing your image, it is good to have a strong border above the head, particularly if shooting or cropping to a square format (see page 138). This will help to give a sense of depth and context to the image and to allow the model to sit comfortably within the frame and surroundings. It is important to ensure that you have perfect lighting on the face (see page 64) as the model's face and eyes are likely to become the central focus of the straight-on image. Make sure that you focus on the face and get the eyes strongly in focus. This will enhance the sense of impact and immediacy in the image, as it will seem as though the model is staring directly at the viewer.

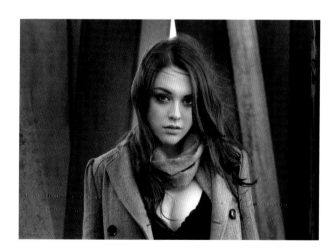


+ Top tip! Try shooting with a shallow depth of field to enhance the feeling of the model popping strongly out of the image.


GET IN CLOSE

When taking portraits, don't be afraid to get in close to the model's face. Filling the whole frame with your subject creates a striking image where the viewer feels intimate and familiar with the model.

Getting closer to the subject helps to eliminate wasted space that can often crop up on a shoot. If the background is messy, or doesn't serve a strong purpose within the image, it can create a visually distracting shot that jars or feels cluttered. If the model is too small within the frame of the photograph, it can also appear as though they are floating in the space, drowned by their surroundings. By getting in closer to the model, you eradicate these issues and create a cleaner image with a stronger impact.

Close-ups also allow you to highlight unique features and the imperfections which make each model's face interesting and personal. Particularly when shooting in high resolution, you can really highlight all of the textures, wrinkles, and tiny individual features on a face that begin to build a picture and tell a story of the individual. Close-up images can be hugely emotive and striking and are definitely worth adding to your catalog of portrait shots.

"Close-ups also allow you to highlight unique features and the imperfections which make each model's face interesting and personal."

+ **Top tip!** If you didn't manage to get a close up image on the shoot, try creating a tight crop in post-processing.

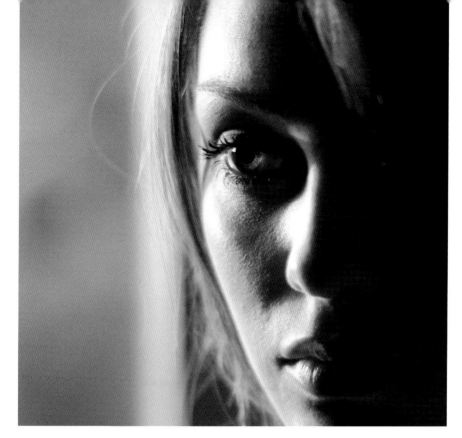

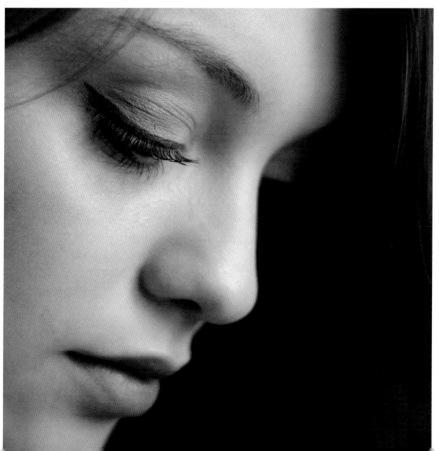

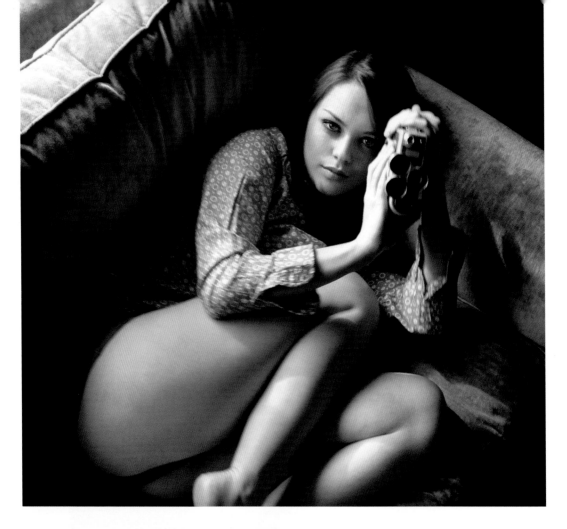

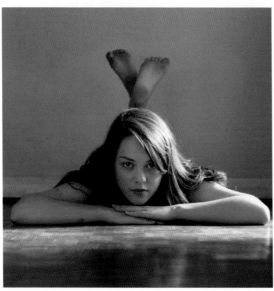

"The angle can create a feeling of a model being strong, vulnerable, playful and much more!"

UNUSUAL ANGLES

A great way to add a different perspective to your photographs is to play around with unusual angles. Your camera acts as the viewer's eye and therefore by modifying the angle at which the model is shot, you can change the perception of the image that is being seen, creating a story of why the viewer is up high, down low, or to the side. Unusual angles will not only change the appearance of the model and surroundings, but also add intrigue and a story to your shot.

Experimenting with unusual angles can be a fun and creative process. Very often we get used to shooting a model from a 45-degree angle (see page 110) as it is naturally flattering for the face, but it can be a freeing experience for both model and photographer to play around with an unusual positioning of the camera. At the end of a shoot, when you're comfortable with the model, try positioning yourself down low, up high, or moving the camera onto a slant to create a different look and feel. By moving the camera to unusual positions, the model will often become freer and more creative in their posing as they follow the camera around.

Make sure to consider your surroundings when experimenting with angles to create a cohesive image. For example, if shooting outdoors, try shooting upwards from the ground and ask the model to throw leaves in to the air. The leaves will cascade down towards the camera with the model above creating a fun, playful image. It is worth also considering the story you are trying to tell. As the model is often the central figure, play around with how different angles make them seem. The angle can create a feeling of a model being strong, vulnerable, playful and much more!

Top tip! Try bringing a small stepladder or footstool with you on a shoot. The highly elevated angle can create some really interesting and creative shots.

SHOOT AT A SLANT

Shooting at a slant is a great way to create a fun and unique portrait or full-length photo. When out with a model on a shoot, try tilting the camera slightly for a few of the photos for a quick and simple way to create a different and quirky effect. Be careful not to slant your camera too intensely—a slight tilt of about five or ten past the hour is sufficient.

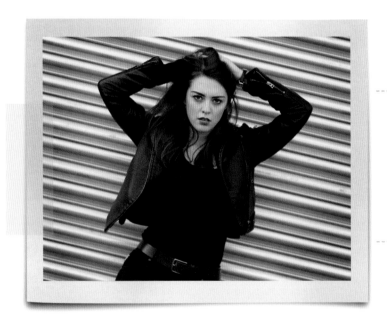

Shooting at a slant works particularly effectively in front of vertical lines. By turning your camera slightly, the harsh lines are dispelled and it helps to create interest and movement in the image. You can intensify the slanted effect by asking the model to stand straight so they are in line with the verticals behind.

When finding a background for your tilted photograph, try to make sure it's not too busy or cluttered. As the slanted photo is already asking the viewer to work a bit harder with the image, you want to make sure the focus can still solely be on the model or subject. Photos at a slant work well when paired with playful, fun poses. Get the model to lean into the camera and experiment with placing their hands in their hair and moving while you're shooting photos.

+ Top tip! Try a tight crop in post-processing with your tilted images to make the slant appear less intense.

"A slanted photo is already asking the viewer to work a bit harder with the image, you want to make sure the focus can still solely be on the model or subject."

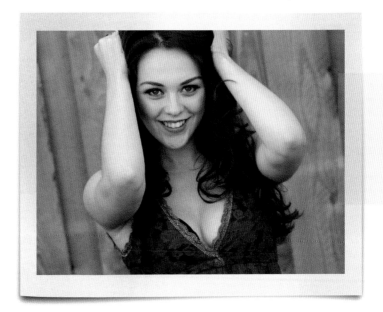

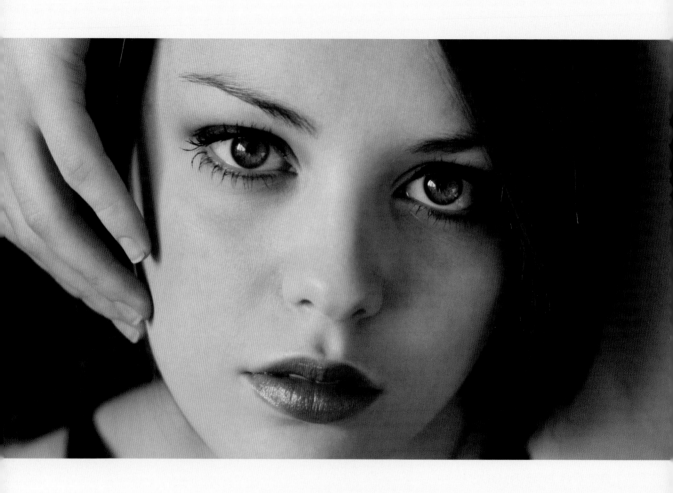

POSING

STRONG | VULNERABLE | EXPRESSIONS | HANDS | PROFILE

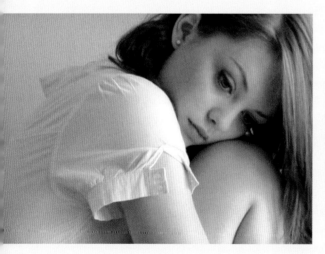

STRONG

The way a model is posed within an image is fundamental to creating an impactful photo with an idea and story behind it. As the model will often be the central character and focal point of the image, effective posing can help to give the background of the image context and meaning. The viewer can empathize with the emotion the model is portraying, both facially and with their body, and will start to feel a personal connection with the character portrayed.

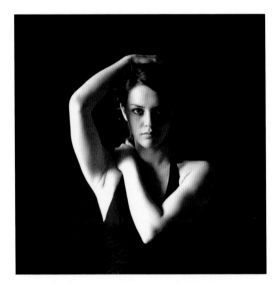

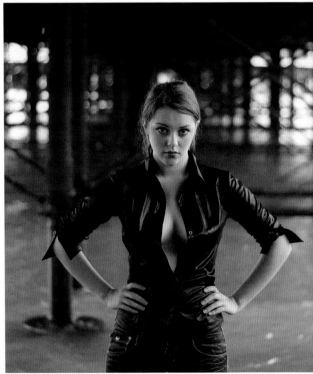

An easy way to create a visually arresting and striking image is by asking the model to have a strong pose. This will instantly create the feeling that they are in control of the image and the surroundings and will draw the viewer's eye to the strong, very present character presented.

A simple way to achieve this is by asking the model to stand with a wide stance (just wider than hip distance) and to put their hands on their hips. This expands the amount of space the model takes up within the image and makes them seem bigger and more visually arresting in the space.

Shooting while the model is walking toward you with purpose can also work effectively to create a strong look and pose. Ask the model to take wide strides and make sure they are looking directly into the camera as they walk. The eye contact can work particularly effectively as it will feel as though they are commanding the space.

Top tip! Make sure the model's facial expression pairs with their pose. When creating a strong look the intensity of the eye contact is particularly important.

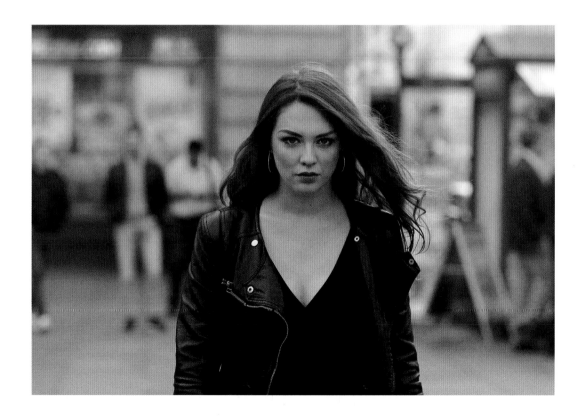

"Create a visually arresting and striking image by asking the model to have a strong pose."

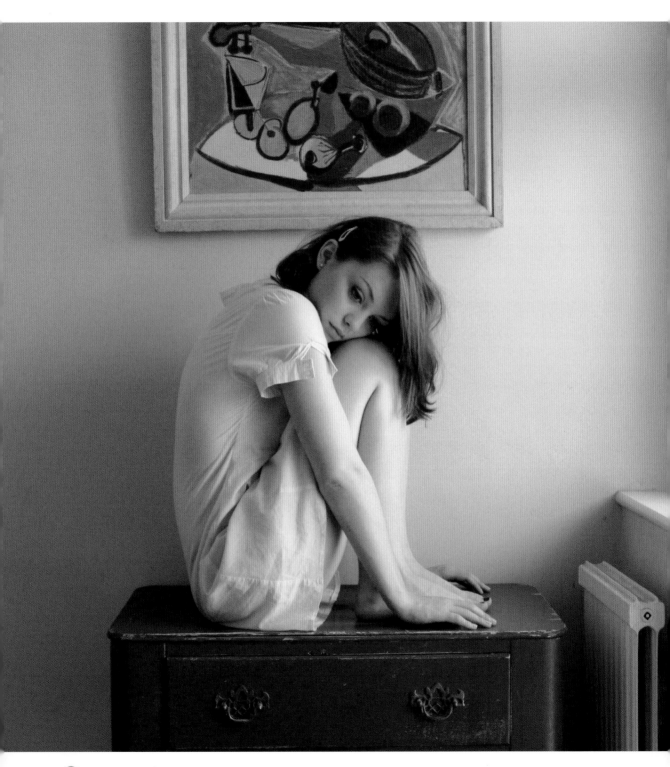

VULNERABLE

Some of the most visually memorable images are the ones that present the fragility of human nature. Often in artwork, we are drawn to the images that touch the most difficult and vulnerable moments in our lives where we feel most alone and without the means to express ourselves in words.

+ **Top tip!** Expressive poses will begin to tell a story and you can heighten this further by creating a scene for the viewer to build a story around.

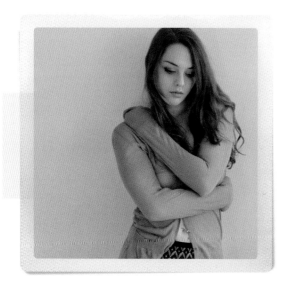

A vulnerable pose will help to create an incredibly emotive image. Often this feeling is created most effectively by making the model appear very small within the image. Ask the model to crouch down on the ground so their body will appear smaller. This can also allow for more background space surrounding them.

Creating a slightly hostile feeling with the limbs also works effectively for a vulnerable feel. Ask the model to cross their arms or legs or shelter themselves with their limbs. By placing the arms across the body you can create a sense of insecurity or that the character presented needing to protect themselves, which will add to this vulnerable effect. Turning the head away slightly so the face isn't in direct view of the camera can also amplify this effect.

"By placing the arms across the body you can create a sense of insecurity or the character presented needing to protect themselves."

EXPRESSIONS

Expressions are a great way to relax your model into a shoot and create some fun and striking images. A series of different expressions of a single model can create a really lovely set of images that are playful, intriguing, and show different sides of a model's personality.

When focusing on expressions for your shoot, make sure to choose a plain background so your model's expression can be the focal point of the image. It is often also effective to shoot head and shoulders to minimize any distraction in the photo.

+ Top tip! In post-processing, create a triptych of three contrasting expressions for a fun set.

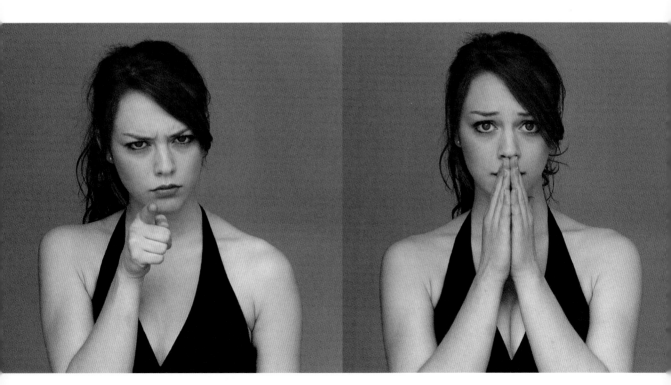

"Ask your model to pull as many different faces as they can think of and snap away as they do so. "

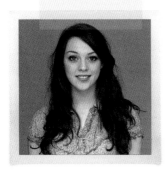
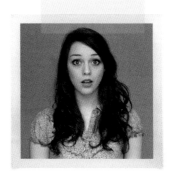
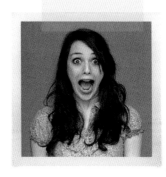

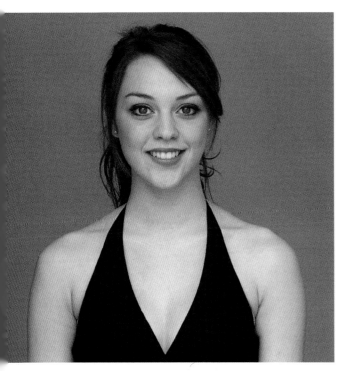

Ask your model to pull as many different faces as they can think of and snap away as they do so. It's useful to have some cut outs from magazines or photos you have found online to jog the memory and spark new ideas.

If your model feels comfortable, try some silly faces as well as standard expressions. It can often work as a good icebreaker when working with a model for the first time and can help to create a more relaxed working relationship where you can both take more risks.

HANDS

Hands are an incredibly expressive part of the human body. It is with hands that we hold another to show love and warmth, to comfort or console. Our hands can also be used as powerful weapons to inflict harm on objects or people. It is frequently with our hands that we also convey feelings of unease or awkwardness. It is therefore important when working with a model to consider the placement of the hands as well as the expression they are communicating with their face.

"It is worth considering the emotion you are portraying with the image."

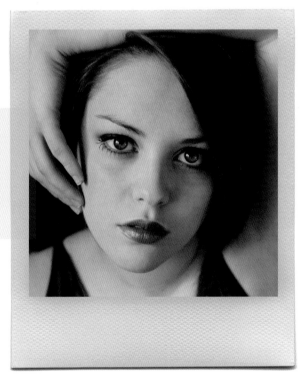

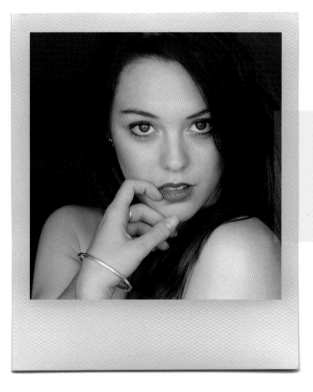

It is worth considering the emotion you are portraying with the image and spending a little time working on how the hands will best convey this. Often a model will use their hands instinctively, however, it is worth practicing being meticulous with details. If you are looking for a very natural, relaxed shot make sure there isn't too much tension in the model's hands. Alternatively, if you are trying to convey grief, anger, or unease in your photo, tense hands that are clawed or holding tightly onto an object or another part of the model's body will help enhance this feel.

Beyond being a tool for expressing emotion within a photograph, hands can also be used to frame the face or to add interest to the picture. When shooting a portrait, by bringing the hands up toward the face or hair it helps to create a more interesting picture with an added sense of movement or context. By placing the hands lightly round the face you can create a natural frame that will draw the viewer's eye into the model's face.

Hands can also be used to enhance a candid look in your photography. By asking the model to hold an object or to play with their hair you can create the feeling of the model being caught in a natural state and begin to tell a story with your image.

Top tip! Remember to consider the detail when including hands in the shot. If you are shooting close-up, watch out for chipped nail varnish and jewelry, and make sure it fits with the kind of photo you are trying to take.

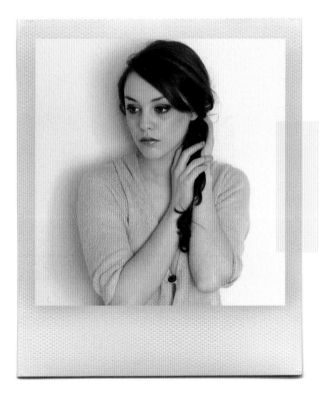

129

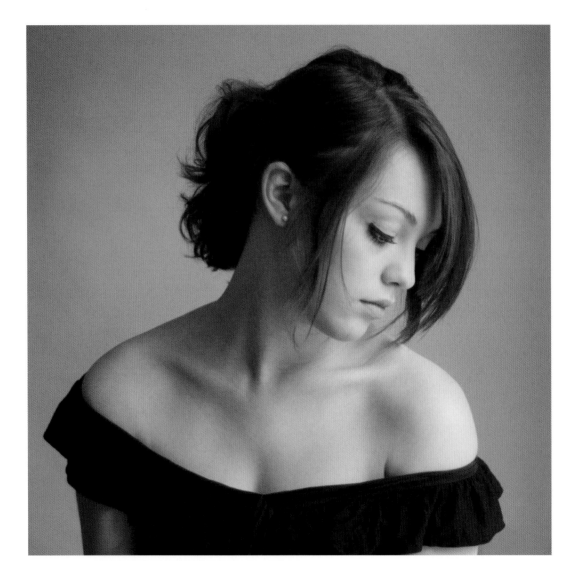

"For a classic portrait look, ask
the model to turn their head
completely to the side. "

PROFILE

Shooting a model in profile is a classic and beautiful technique that has been used for centuries by artists and photographers alike. Works such as Vermeer's *Girl with a Pearl Earring* use this elegant, intimate position. The position will work effectively with any model and will help to add shape and definition to the face and picture.

For a classic portrait look, ask the model to turn their head completely to the side. This will accentuate the neckline and will create an elegant and classic look. To enhance this further, compose the photo so it only includes the model's head and shoulders and keep the neck and chest area as clear as possible.

+ Top tip! Try a close crop, filling the image with the model's face, for an intimate, sensuous feel.

By zooming out and including more of the model's body and surroundings in the photo, you can create a distant, faraway look. Rather than the classic, elegant profile image, this will create an impression of the model looking away from the camera and being lost in their own thoughts or distracted by something they can see out of shot. The viewer will wonder where the model is looking and start to build a story around the model's expression and the setting they are in.

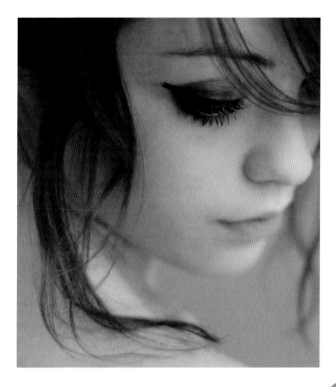

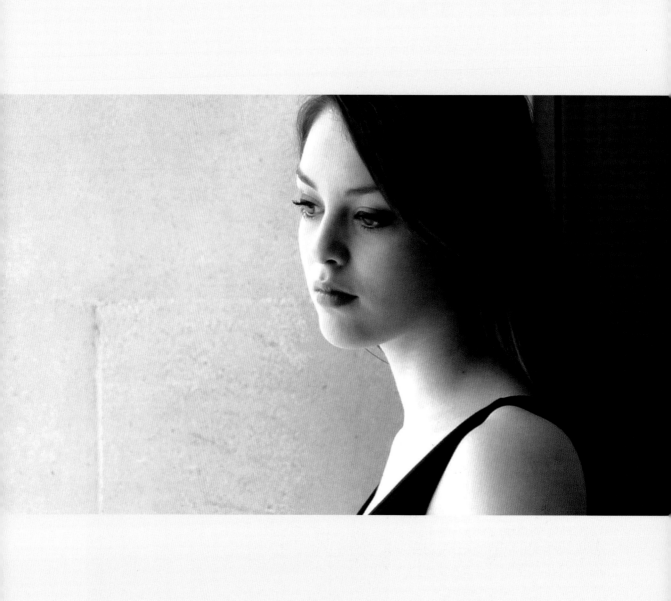

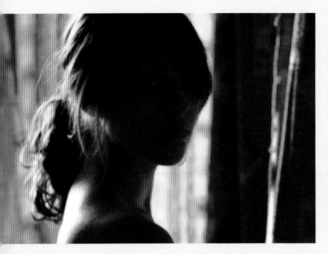
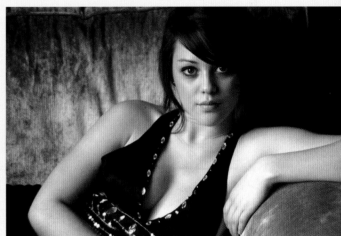

PORTRAIT | LANDSCAPE | SQUARE

CHOOSING A FORMAT

PORTRAIT

The portrait format for photographs, perhaps unsurprisingly lends itself particularly well to photographs of people! This is because the human body is taller than it is wide, and therefore fits naturally within this orientation. When shooting just the face, or the head and shoulders as in a classic portrait shot, the same idea applies. As the face is longer than it is wide, it fits easily within a portrait frame.

One of the reasons a portrait format works so well in portrait photography is due to the way in which the model's body will fill the entire frame. The narrow crop eliminates much of the space surrounding the focal point of the image creating a clean, strong composition and forcing the viewer's eye to the model. By providing less space for the background, it is less likely for the photo to feature distracting or noisy visual material, allowing the viewer to focus on the subject of the image.

When shooting with a portrait frame it is good to place the model's eyes in the top third of the image. This creates a natural composition, similar to how we would observe someone in everyday life and will add to the sense of a life-like depiction of the person within the image.

> "Try to place the model's eyes in the top third of the image."

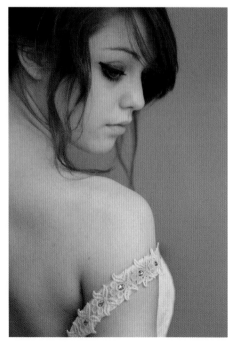

+ Top tip! Make the most of the sense of height created by the portrait frame by asking the model to jump while you shoot. This can be a great way to create a sense of movement.

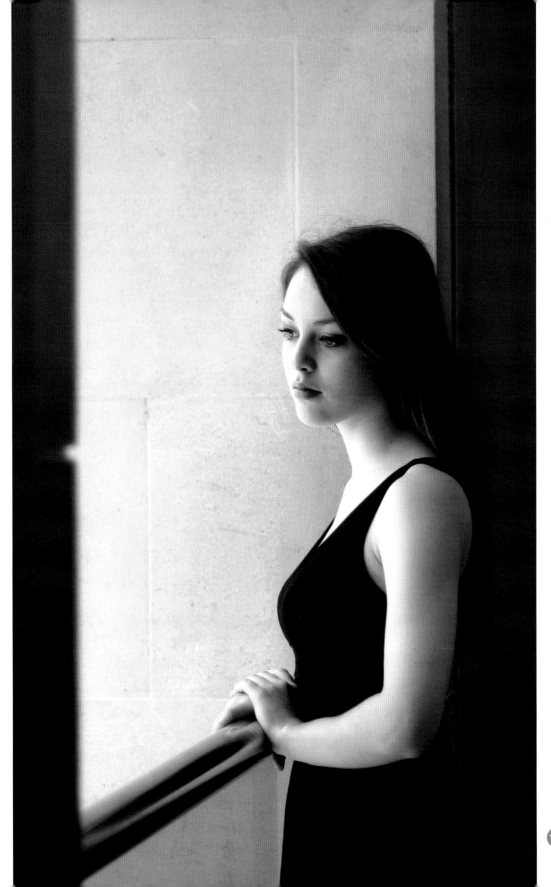

LANDSCAPE

A landscape frame is so named as it has often been used as a strong way to compose a landscape, allowing a sense of breadth to the image and for as much of the natural vista to be included as possible.

The landscape format, however, also works effectively when taking a portrait. The horizontal composition allows more space for the background around the subject. This allows the photographer to create a strong sense of context and story by no longer focusing purely on the model themselves, but also on their location and how they fit contextually within it.

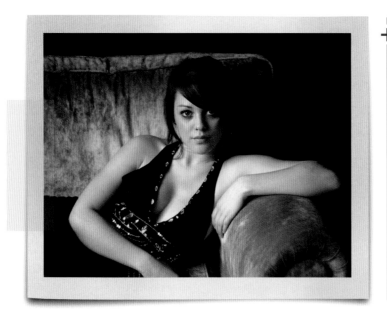

+ Top tip! A simple way to compose a landscape image is by following the rule of thirds (see page 96). By placing the model along one of the outside lines, they will sit effectively within the background surrounding them—allowing room for both elements to work to their full potential.

By including more background within the image, you are able to tell a strong story which goes beyond the expression of the model's face and pose. By placing the model off center, you create a sense of where they fit within their surroundings. To create an effective landscape shot, consider the model's outfit, face, and pose in relation to the background behind. You will need to decide whether you want the two to complement each other, or work in juxtaposition to one another. Both effects will start to build a story around the image, inviting the viewer to ask themselves why the model is in the location and what they are thinking and feeling.

"To create an effective landscape shot, consider the model's outfit, face, and pose in relation to the background."

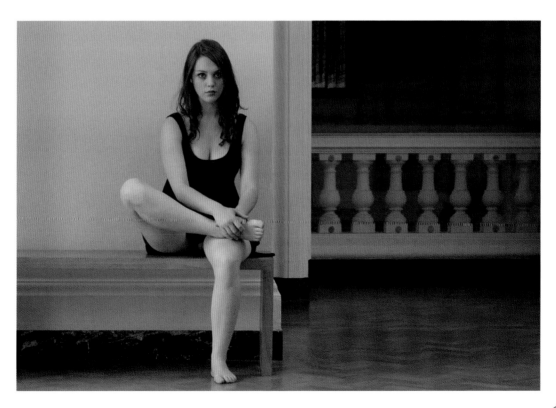

SQUARE

The square crop has exploded in popularity since the introduction of apps such as Instagram, which focus almost entirely on the square shape. However, square crops don't just need to be used within an app. Try shooting on a square setting or cropping your photos in post-processing for strong, well-balanced images.

One of the advantages of the square frame is that it is relatively easy to create a well-composed photograph. The even shape allows the eye to easily move around the frame and take in the whole of the photo, making busy shapes and scenes easier to view and less cluttered to the eye. By cropping to a square from a rectangular frame, you have the option to remove empty, unnecessary space in the photograph making it appear tighter, more striking and elegantly distributed throughout the frame.

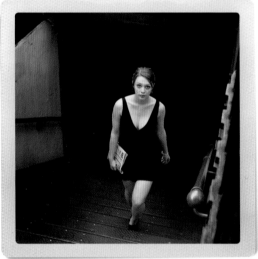

"With a square crop, the subject can be placed directly in the center for a striking and arresting image."

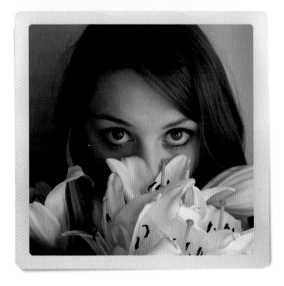

Top tip! The square format is great for Instagram and provides a fantastic way to share your images with friends and to gain a following.

Another advantage of the square frame is that a subject can be placed directly in the middle of the photograph. With a rectangular frame, it is often advisable to follow the rule of thirds (see page 96), avoiding the center of the frame; however, with a square crop, the subject can be placed directly in the center for a striking and arresting image.

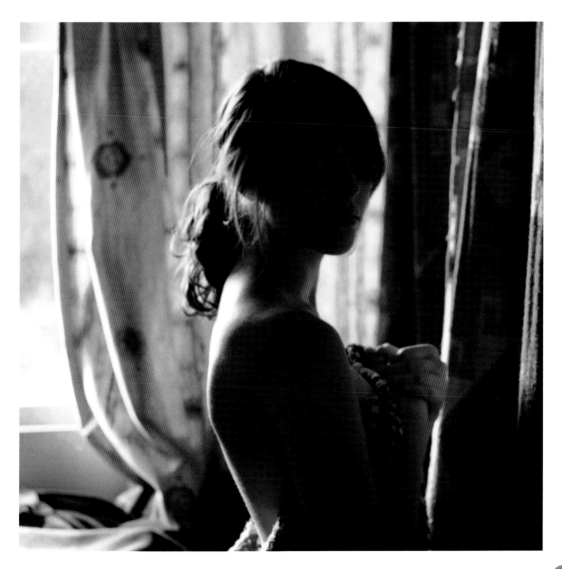

DIFFERENT FACES

The techniques in this book are applicable in a wide range of settings and can be used with any models you are working with. The following chapter provides examples of how some of the ideas have been used in different locations with different models and aim to spark inspiration for the varied ways the techniques can be applied to your photography.

 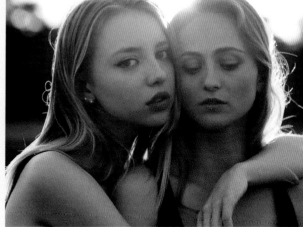

TRY A THEMED PHOTOSHOOT

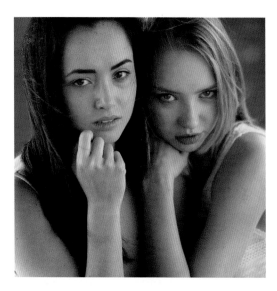

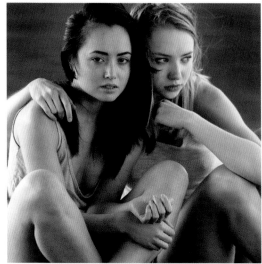

In this series of photographs a thematic look and feel has been used for all the images. Two models of a similar age and look have been used both for individual portraits and together and have been directed to appear as though they are close and comfortable with one another. The clothing is a uniform style and has been kept plain so the focus can remain on their faces, poses, and the interesting location.

"The mood, outfits, location, and the square crop create a cohesive, themed set of images."

A large focus in these photos is the unusual background. The photos were taken underneath Brighton Pier, but the close square crop and short depth of field leaves an element of intrigue to the images. The background is not clearly explained or shown and this allows the viewer to create their own story and context. The set of individual and group pictures are drawn together through the mood, outfits, location, and the square crop, creating a cohesive, themed set of images.

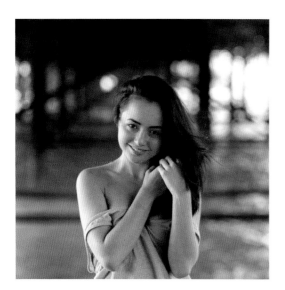
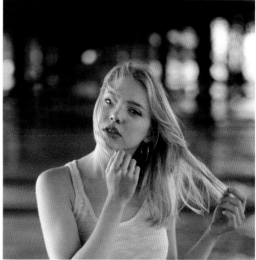

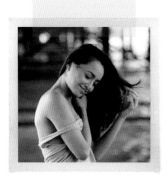
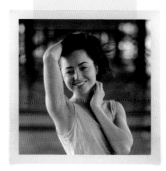
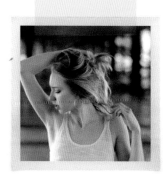

USE A PROP

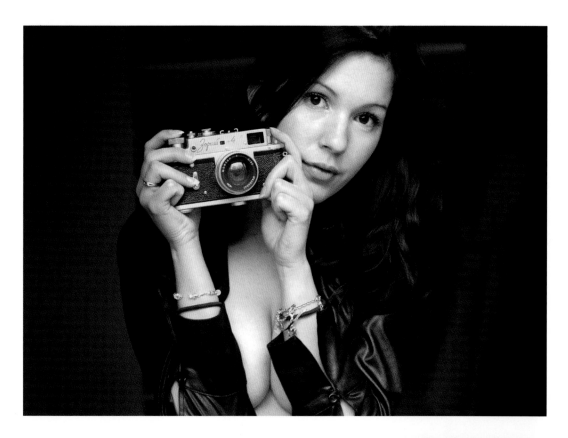

In all of these images of Helena, the props are used to help tell the story of the image. In the first image, a candid effect is achieved by Helena peeping round the side of the camera, as though she has been caught in the middle of her action. The camera placed near her face also helps to draw the eyes up towards hers. In the second image, the statue mirrors Helena's pose and invites the viewer to ask questions, creating an unusual feel and a sense of intrigue.

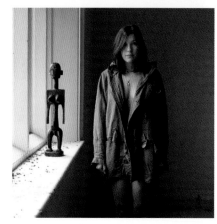

"Props are used to help tell the story of the image and invite the viewer to ask questions, creating an unusual feel and a sense of intrigue..."

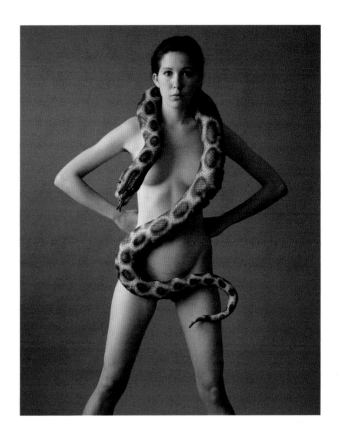

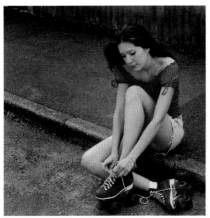

In the snake image, a prop has been used as a wardrobe choice and has therefore become a strong focal point of the photo. By placing the toy snake in a curved position across Helena's body, the eye is invited to travel up and down the snake and Helena's figure, enhancing her curves. In the final image, roller skates have been used to create a fake candid effect. By directing Helena to tie up the shoe laces it feels as though the viewer has stumbled across a natural scene.

CHANGE YOUR WARDROBE

In these photos, Charlotte appears in two visually similar settings. Both scenes provide a pale, architectural background upon which the eye is strongly drawn to Charlotte as the subject. However, the choice of wardrobe greatly changes the overall feel of the image. The pale, silvery dress blends into the white and gray background, allowing Charlotte's face and hair to be a clear focal point of the image. The style of the dress, coupled with her poses also feels very light, graceful, and feminine.

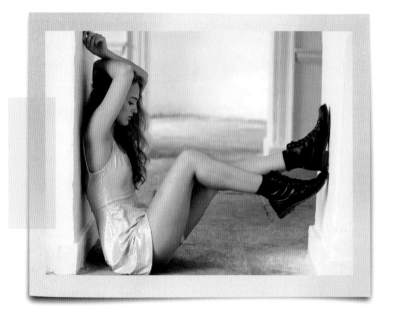

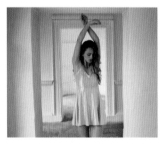

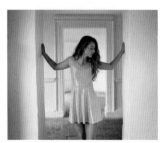

"The choice of wardrobe greatly changes the overall feel of the image, sparking new imaginative ideas for the backstory."

In the second set of images, the colors of Charlotte's clothes contrast with the background, drawing the viewer's eyes to the outfit as well as Charlotte's face. The graphic t-shirt paired with denim and leather creates a more urban feel. This changes the way the viewer interprets Charlotte within the background, sparking new imaginative ideas for the backstory.

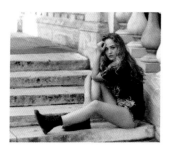

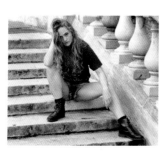

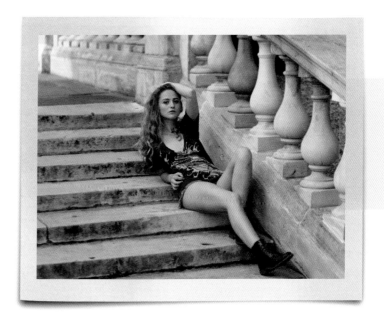

GOLDEN HOUR

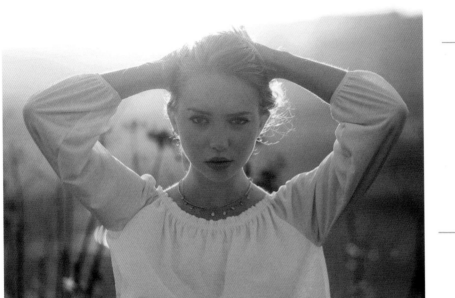

The photos of Helen taken during the evening golden hour create a beautiful warm, soft effect. The quality of the light at sunset has a golden glow which shines beautifully through her hair, creating a halo effect. The natural, outdoor settings help to add to this soft effect and the glowing light catches beautifully on the plants behind. The simple, block shade of Helen's blouse allows the beautiful surroundings and her face to be the focal point of the image.

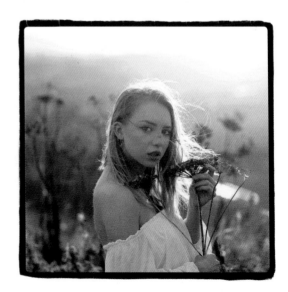

"The quality of the light at sunset has a golden glow which shines beautifully through her hair, creating a halo effect."

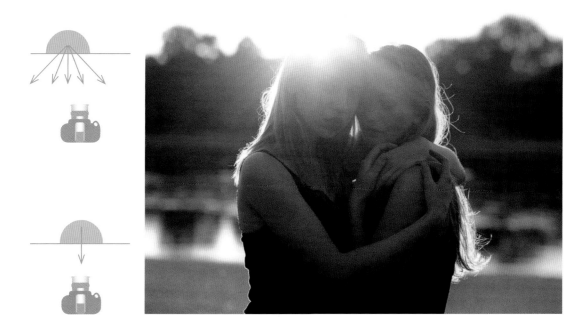

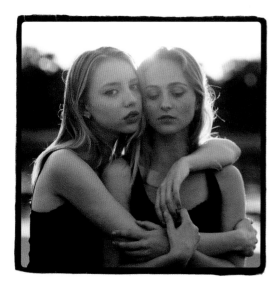

Similarly, in these two images of Helen and Charlotte, simple wardrobe choices have allowed the lighting and the models' faces to really pop out of the image. By shooting into the sun, Helen and Charlotte are able to keep their faces as relaxed as possible, without squinting into the low directional light, creating a natural and beautiful look. The golden glow surrounding their faces and highlighting their hair also works to create a wonderfully soft image.

COLOR MATCHING

The color matching in this image of Helena creates a strong visual impact. The green shades of the wall, chair and dress all draw the image together providing a visually complete look. The white of the windowsills and cream of the floor also match Helena's pale skin, creating a second layer of color matching. The clear divide of the two colors in this image helps to highlight the sense of conflict implied by Helena's distressed pose.

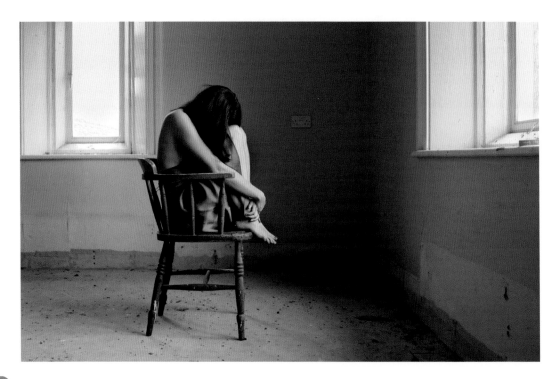

In this photo Helena stands in a relaxed, home setting. The composition, foreground, and background leave much unsaid, inviting the viewer to create a story about why she is where she is and how the photographer came to view her through the open door. The different elements, angles, and objects within the image are drawn together through the color matched yellow sweater and the background of the portrait behind, creating a cohesive feeling to an otherwise slightly mismatched image.

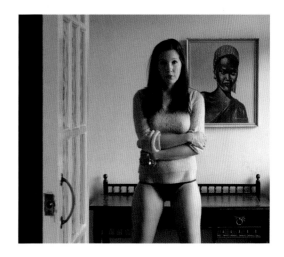

"Different elements within the image are drawn together through the color matched yellow."

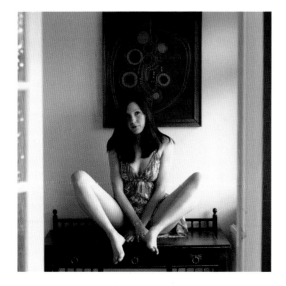

As in the green image opposite, here the clear distinction of two colors is present. The use of red and pink, coupled with Helena's pose, suggests a feeling of sensuality. The white walls and door frame are color matched with Helena's skin. The deep pink color also creates a strong contrast with the pale wall behind. Here, the color matching not only helps to create a visually cohesive image but also adds a flavor of personality and emotion.

CONVERT TO BLACK & WHITE

In these photos of Helen and Charlotte, the color versions both work visually, but are enhanced and improved when converted to black and white. Both of the images have strong levels of contrast—for example pale skin against darker clothing—and these contrasts and shades are enhanced in the black-and-white versions. In the first image, the green background is a weaker element of the photo. Once converted to black and white, the background becomes less distracting, allowing for the emotion in Charlotte and Helen's faces to appear more intensely.

"The color versions both work visually, but are enhanced and improved when converted to black & white."

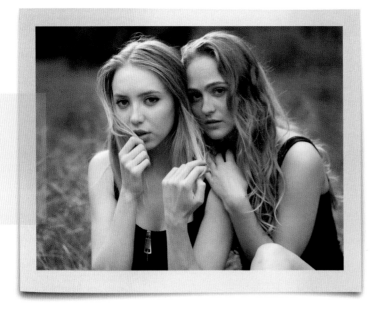

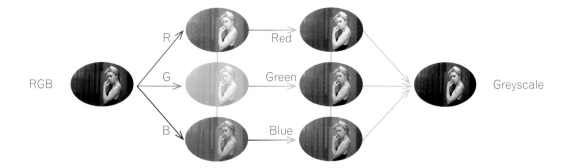

In the portrait of Helen, converting to black and white creates a high art feel. The architectural, textured background works beautifully in black and white, as the lines and shades are highlighted by the variations of gray. The image appears far more dramatic and has a modern feel.

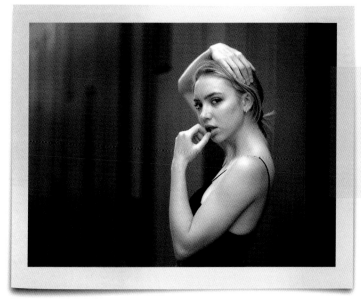

SHOOT AT
45 DEGREES

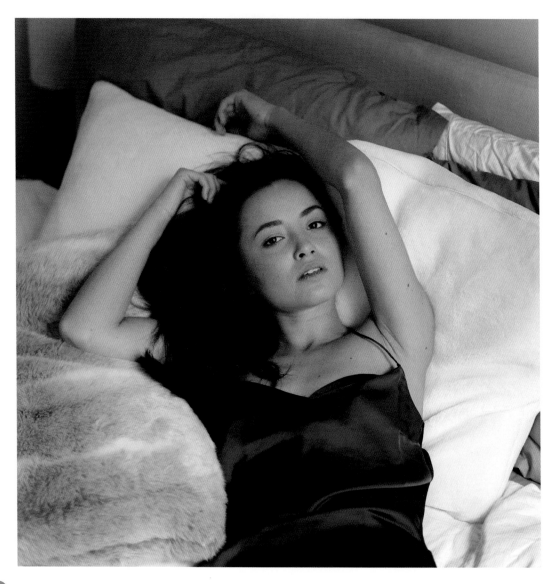

"The downward slant provides a consistently flattering look throughout these images."

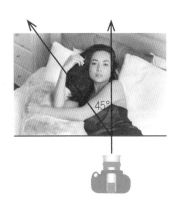

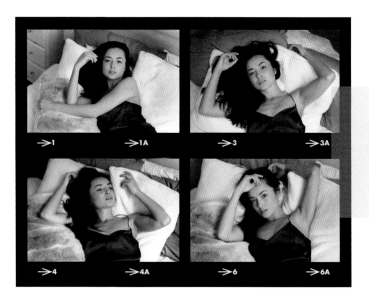

In this series of images, the 45-degree downward angle has been created by Lizzie lying on a bed. Asking the model to sit, kneel, or lie down makes it easy to gain enough elevation to shoot at 45 degrees without the need for extra equipment. The downward slant provides a consistently flattering look throughout these images. For example, when Lizzie looks up toward the camera, her eyes appear larger and wider. The viewer feels as though they are in close proximity to Lizzie and paired with the location this creates an intimate feeling to the shots.

EXPRESSIONS

In the first set of images of Helena, a photographic series has been created by shooting in the same location and outfit with subtle variations on the poses and expressions. By slightly changing her expression, using her hair and arms to add further variation, each photo has a slightly different feel and mood—from sultry, to playful, to reflective.

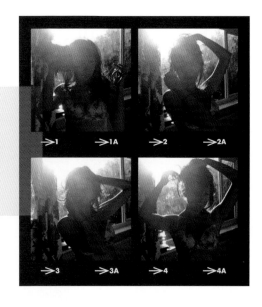

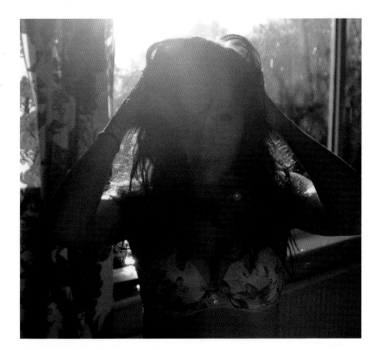

"By slightly changing her expression, using her hair and arms to add further variation, each photo has a slightly different feel and mood..."

In the second set of images, a simple, plain background has been used so the eye is drawn strongly to Helena's expressions. The head-and-shoulders crop also encourages the eye to be drawn to her face. By keeping the background and Helena's look consistent throughout, a varied and fun selection of photos with real personality is created that work wonderfully when shown together.

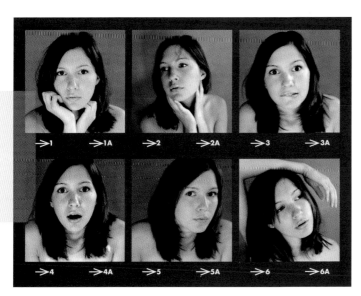

Index

#

45 degrees, shooting at 110–111

A

angles 108–119
 shooting at a slant 118–119
 straight on 110–111
 unusual 116–117

B

backgrounds 84–87
 busy 51
 plain 35
 props 43
black and white 33, 78, 81, 104–105
bokeh 75, 88–89
black dress 50–51
budget 60

C

cameras
 batteries 30
 protection 30
camera shake 75
candid 22–23, 36, 58
catchlight 64
cinematic style 33
color matching, 43, 48, 84, 90–91
context 37,
cropping 87
 landscape 136–137
 portrait 134–135
 square 35, 138–139
 tight 35
crowds 38–39, 103

D

depth of field
 shallow 30, 33, 75, 84

E

expressions 126–127
eyes 34, 91, 106–107

F

face (lighting) 64–65
fairytale effect 29, 54, 58
film 56–57,
film noir 32–33, 48
flare 29
foreground frames 29, 86, 102–103
free lensing 98
frames
 natural 37

G

glass, shooting through 100–101
golden hour 29, 68–69

H

hair 46–47, 69,
hands, posing 128–129
hard light 78–79
haze 54,
halo effect 35, 81

I

interior shots 71
ISO 75

L

leading lines 33, 39, 92–93, 107
lenses 60–61
light 62–81
 artificial 73
 dappled 69
 diffuse 76
 fill 69
 hard 78–79
 low light 72–75

 natural 64
 soft 76–77
 window 80–81

M

makeup 48–49
mirror image 36–37
movement 39

N

night photography 72–75

O

outdoor shots 69, 86
overexposure 30

P

perfect portrait 34–35
personality 34
Polaroids 54–55
posing 120–131
 profile 130–131
 strong 122–123
 vulnerable 124–125

post-processing 30, 87
preparation 30
props 42–43, 90
public, shooting in 38–39

R

reflectors
 natural 29, 37, 66–67
resolution 58–59,
rule of thirds 96–97

S

saturation 30
self-portraits 26–27
shadows 70–71
shutter speed 75
silhouettes 33

Acknowledgments

Many thanks to all of the wonderful people at Ilex who have supported our ideas and enabled this book to take shape.

An overwhelming thank you also goes out to all the people who have supported our work—on Flickr, YouTube, Instagram, in our photography workshops, and now in buying this book. We are enormously grateful for your interest and support and wouldn't be where we are without you!

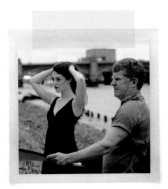

Finally, both Mark and I would like to extend our thanks to our friends and family who have been enormously patient and supportive. Mark would like to particularly thank Sara who has put up with his photographic ideas and projects over the years. Imogen would like to say a special thank you to her friends and family who have allowed their houses to be taken over for our photographic endeavors. You are all wonderful.

snow 28–31
soft light 76–77
storyboard 33
street photography 20–21

T
texture 78
themes 18–19
tripod 75

U
urban settings 86

V
vintage 54, 56

W
wardrobe 44–45, 51
 see also black dress
weather 30
window light 80–81

Picture credits

p66—© Vincenzo Di Maro; Flickr: Vincenzo Di Maro

p67—© Natural Lighting; Instagram: naturallighting101

p140–147—Models: Lizzie, Instagram: lizziedyer.
Helen, Instagram: helenbettyann.
Charlotte, Instagram: charlottesophieturner

All color swatches © iStock